BLACK WOMEN
ADULT COLORING BOOK

Raspiee Coloring

Step into the enchanting realm of Raspiee Coloring!

Embark on a journey of creativity, inspiration, and boundless imagination with our captivating coloring book. We understand that coloring isn't just a leisurely pastime; it's a therapeutic outlet for self-expression and relaxation. That's why we've meticulously crafted a treasury of one-of-a-kind designs to whisk you away on a vibrant voyage.

We extend our heartfelt gratitude for choosing our coloring book and hope it ignites joy and fulfillment as you delve into your artistic endeavors. Thank you for becoming part of the Raspiee Coloring community; we eagerly anticipate witnessing your colorful masterpieces!

Help us and fellow enthusiasts by sharing your thoughts on Amazon through a review.

Best Practices for Coloring

For optimal results, we recommend using colored pencils, as they complement the paper quality provided by Amazon flawlessly.

However, if you prefer markers or watercolors, exercise caution as the paper isn't designed for excessive moisture. To prevent bleed-through or damage to subsequent pages, place a spare sheet of paper beneath the one you're coloring.

Copyright © 2024 by Raspiee Coloring. All rights reserved.

No portion of this coloring book may be reproduced or transmitted in any form or by any means, electronic or mechanical, without the publisher's written permission.

The designs within are original creations of Raspiee Coloring and are safeguarded by international copyright laws.

Let your colors unfurl and your imagination soar!

THIS BOOK BELONGS TO

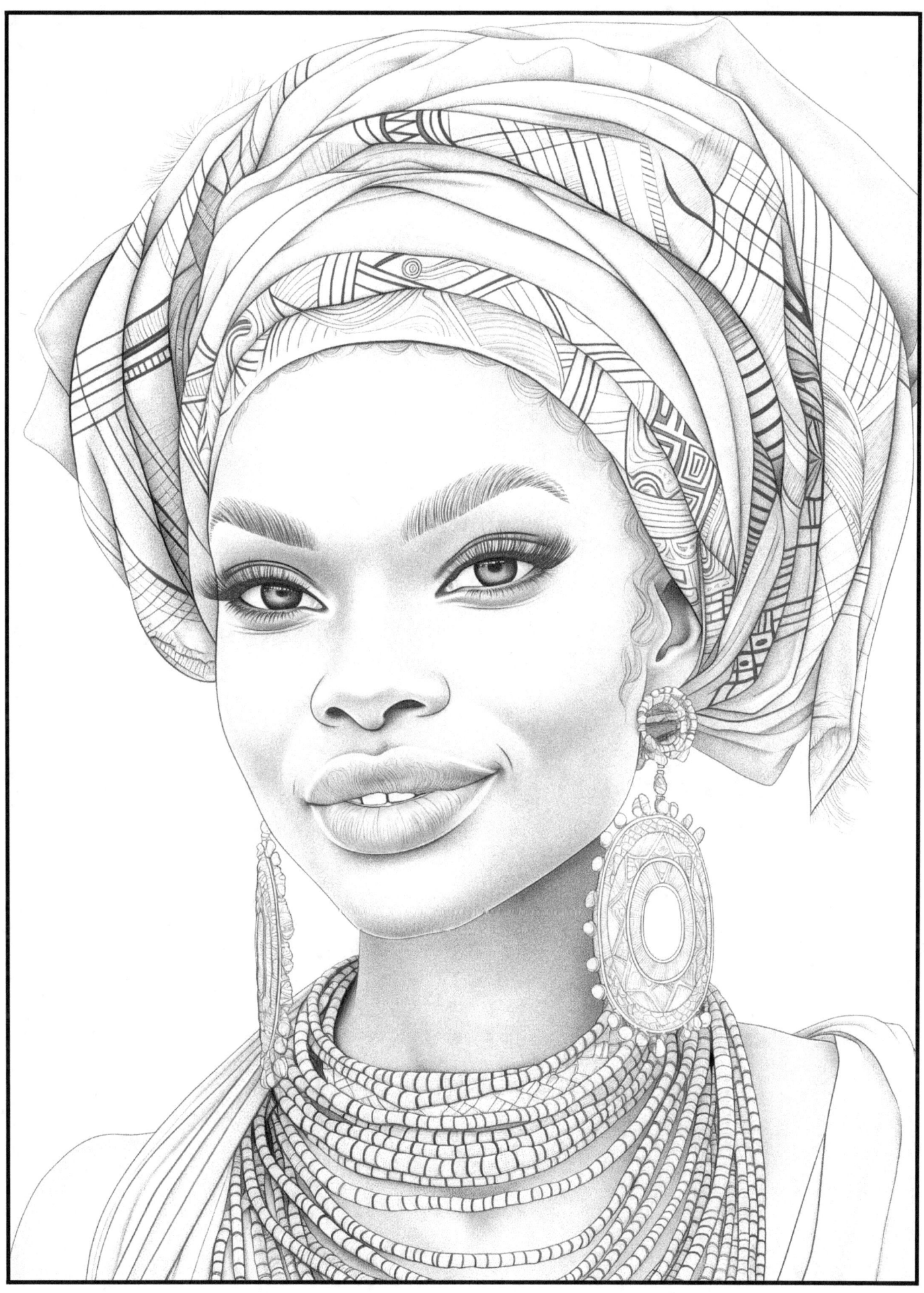

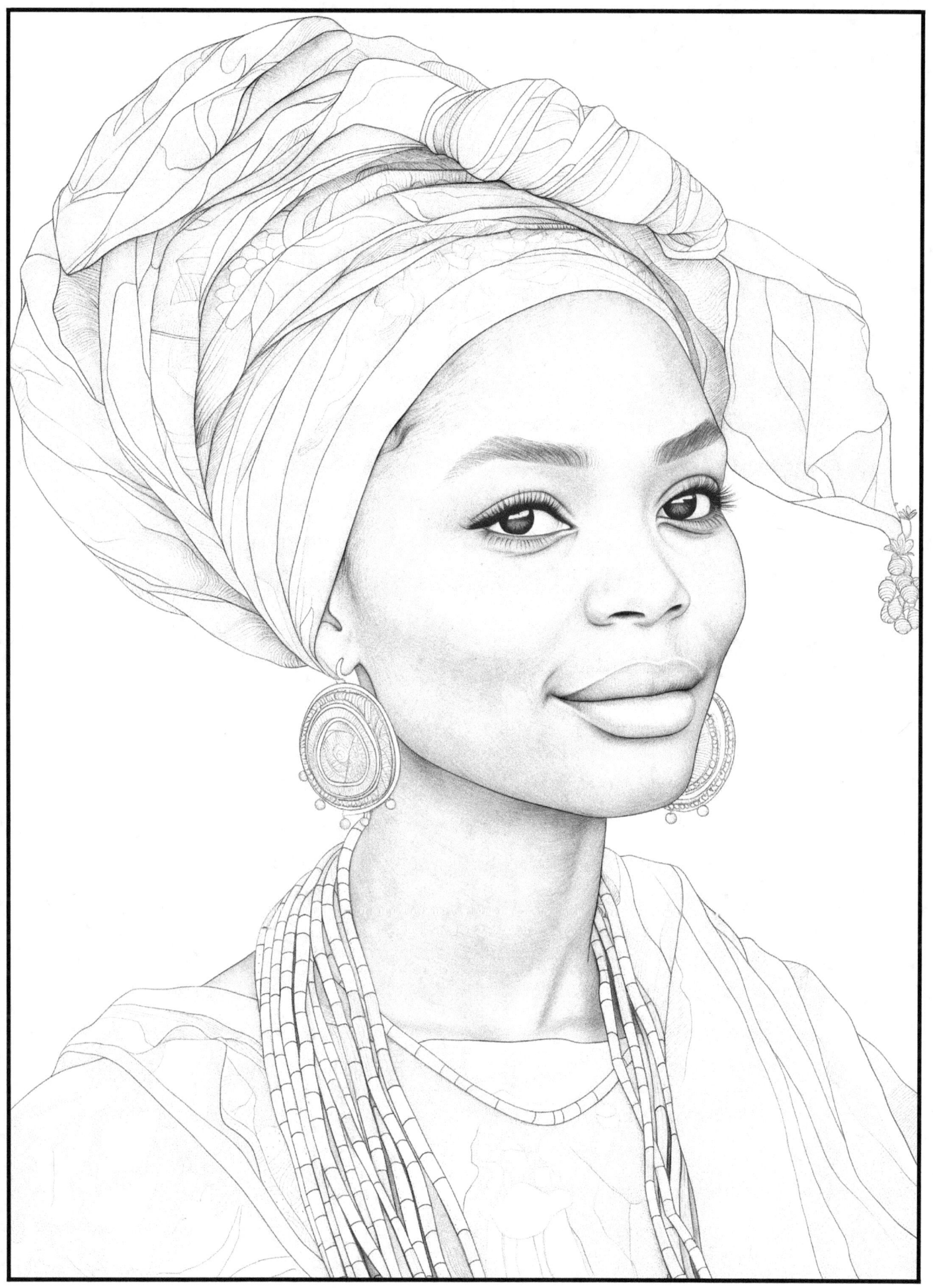

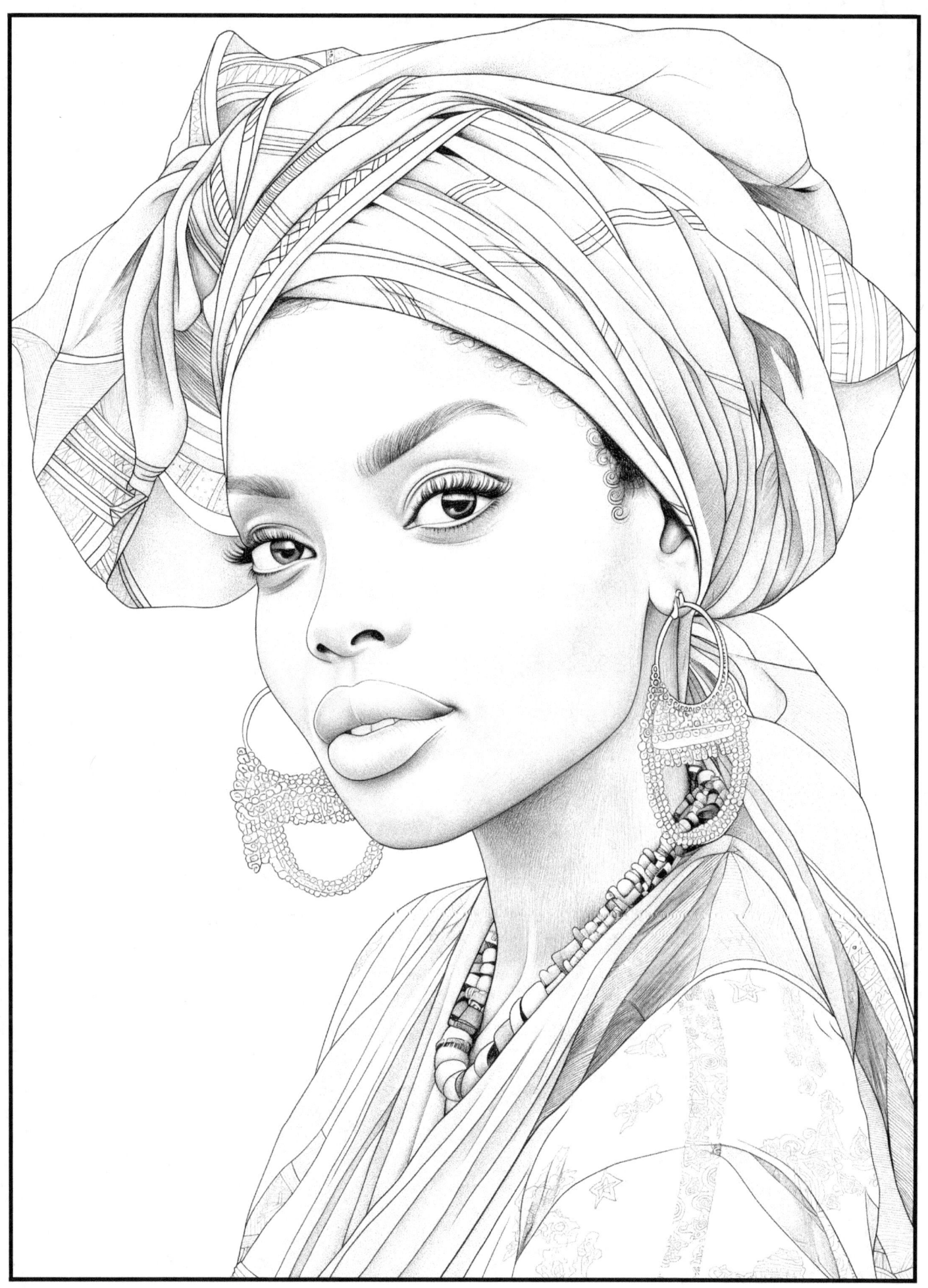

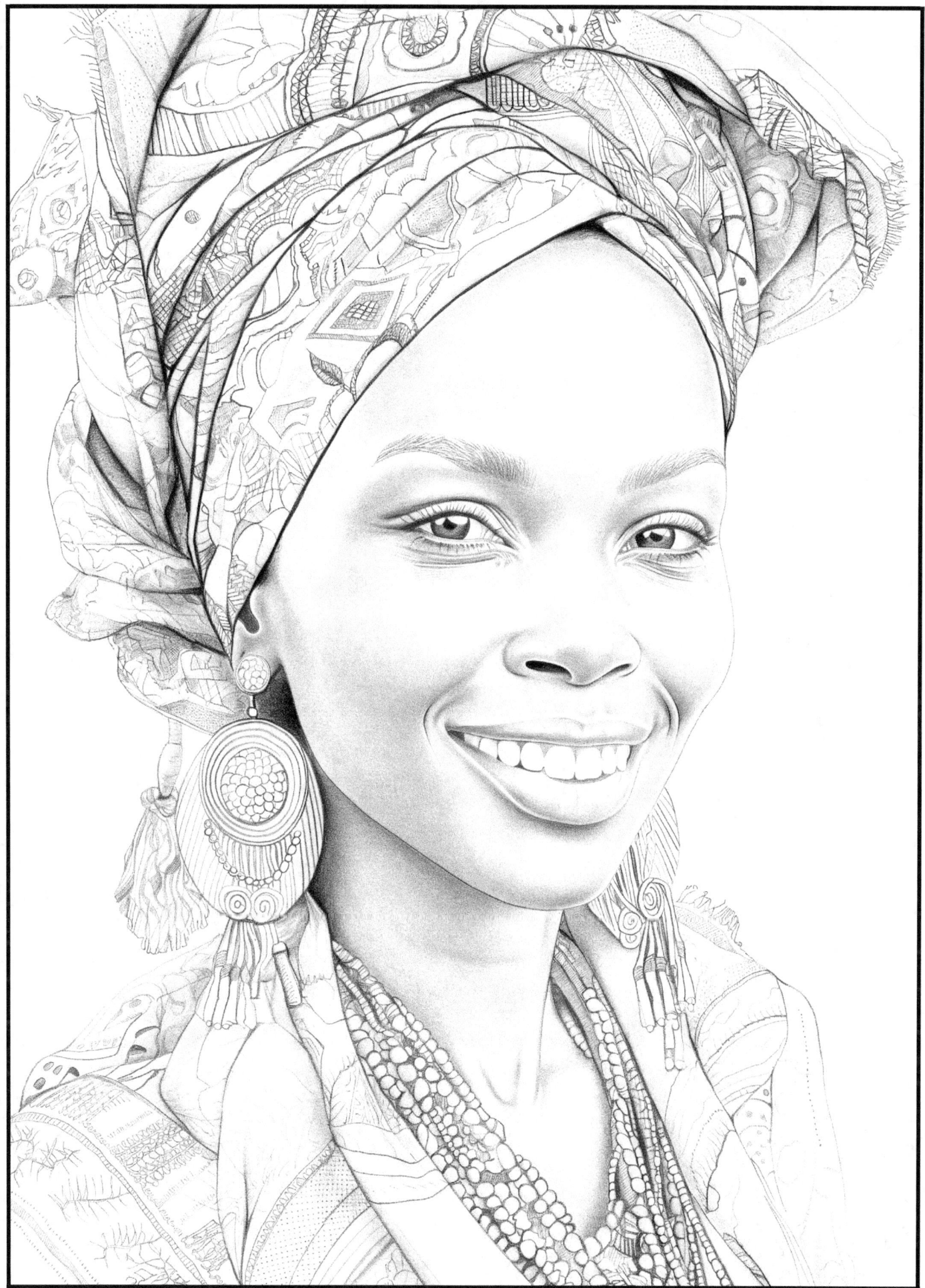

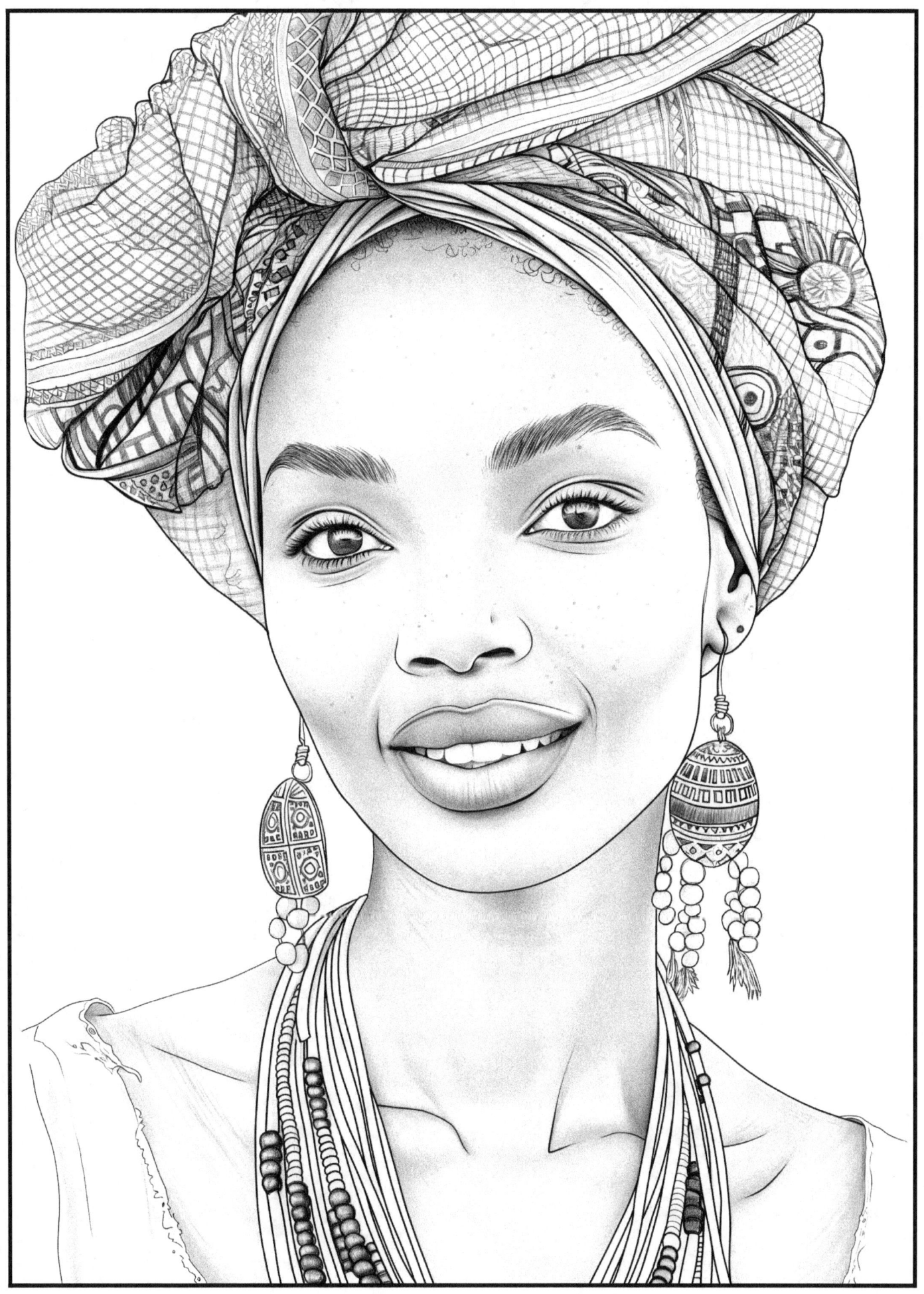

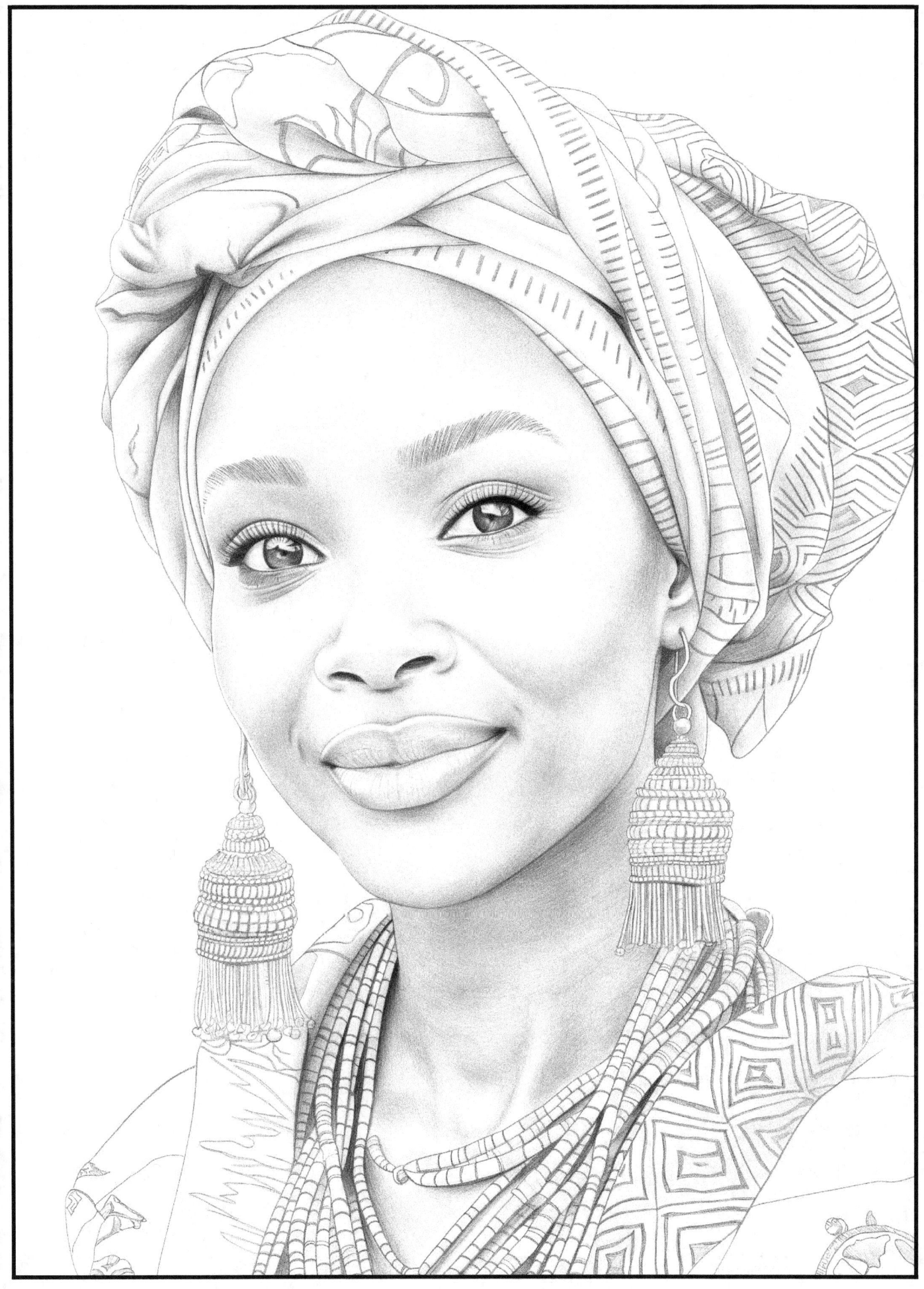

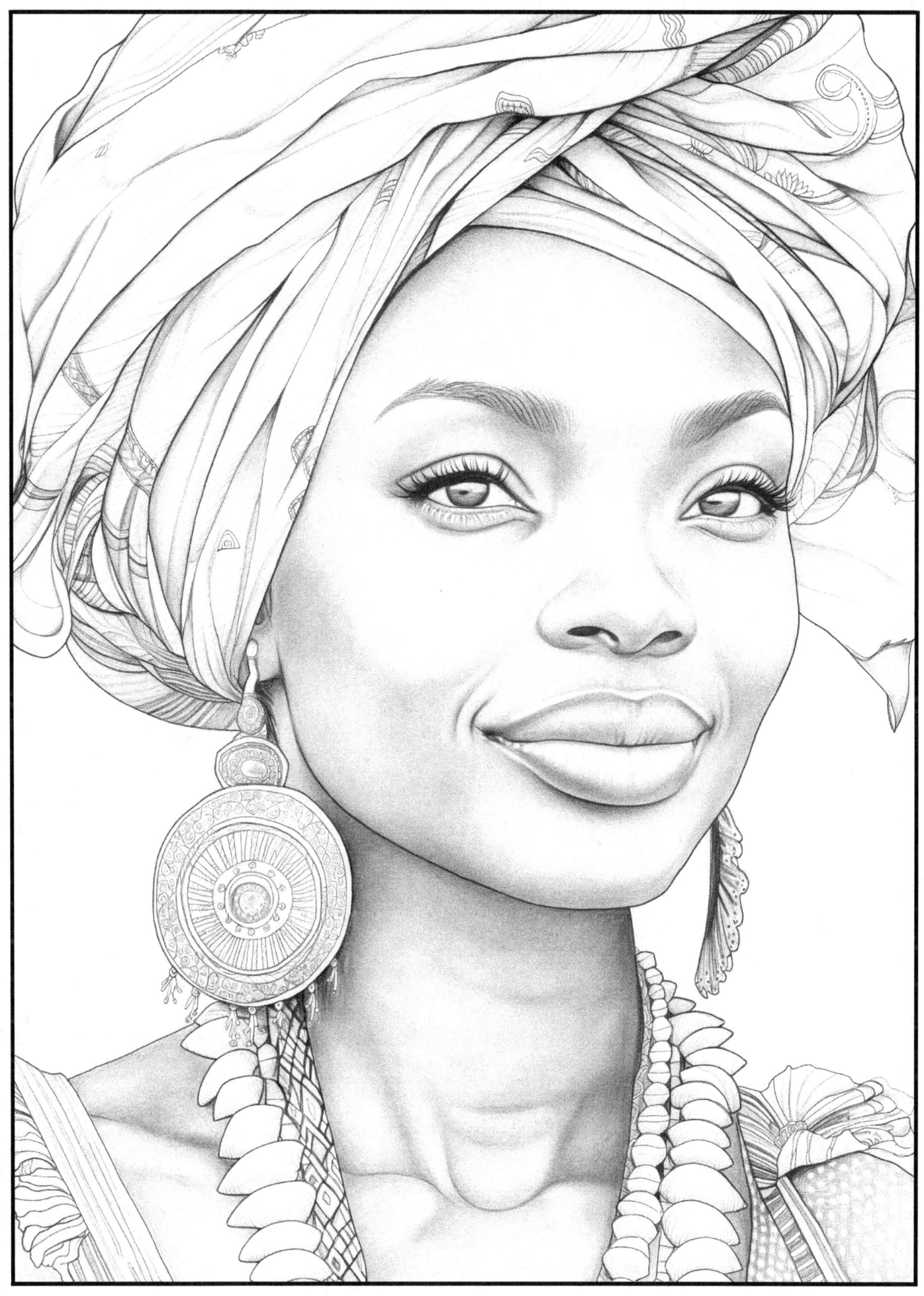

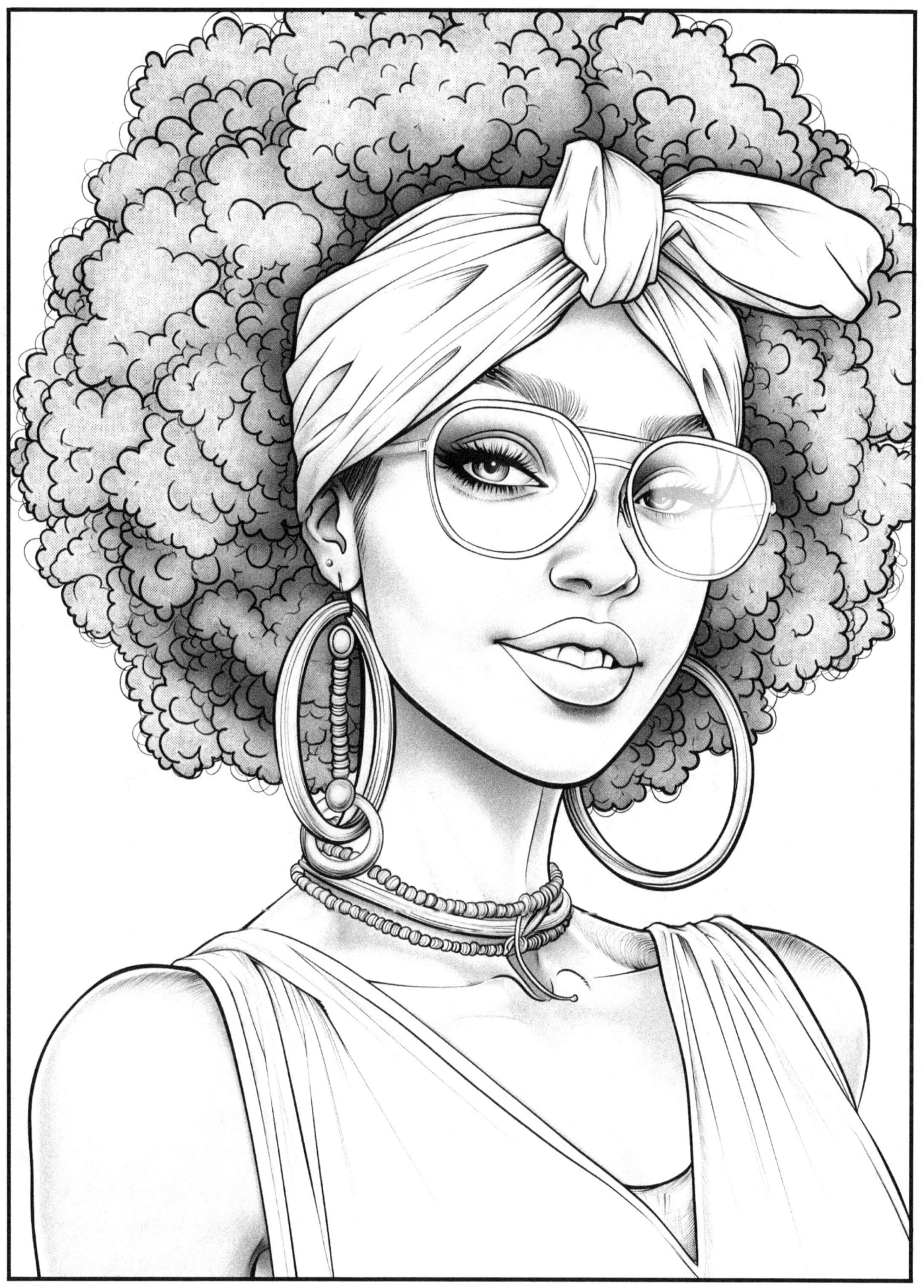

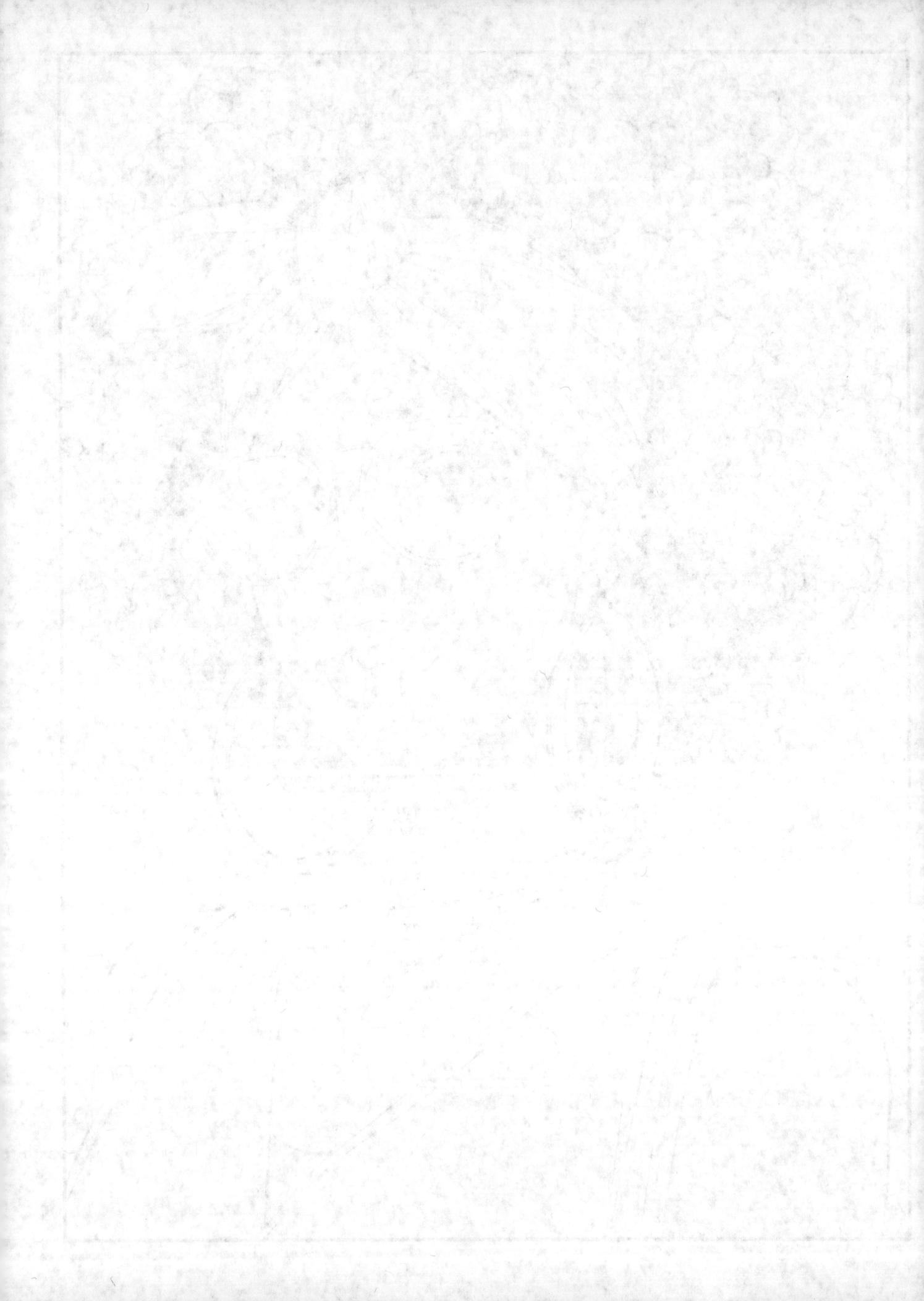

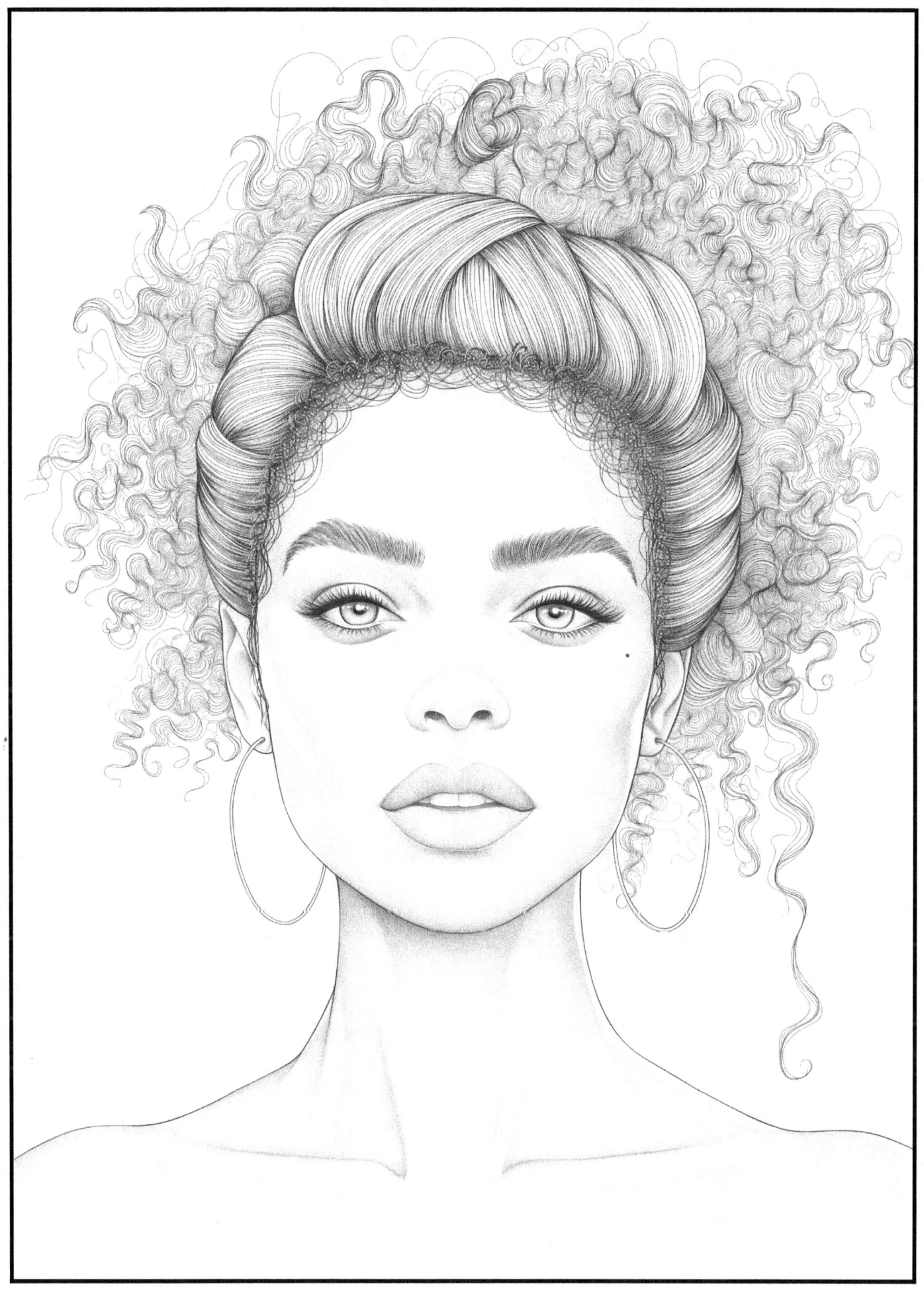

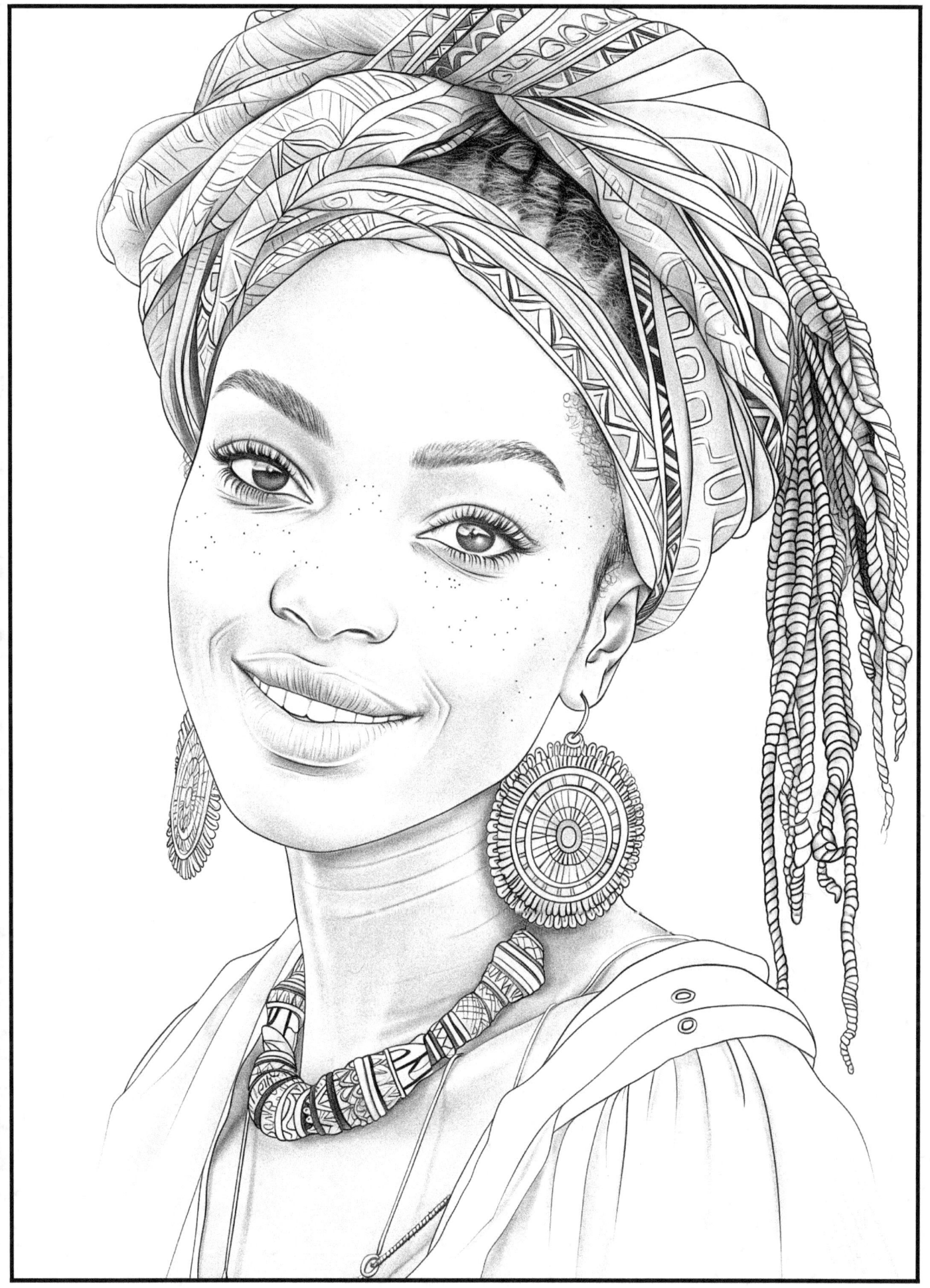

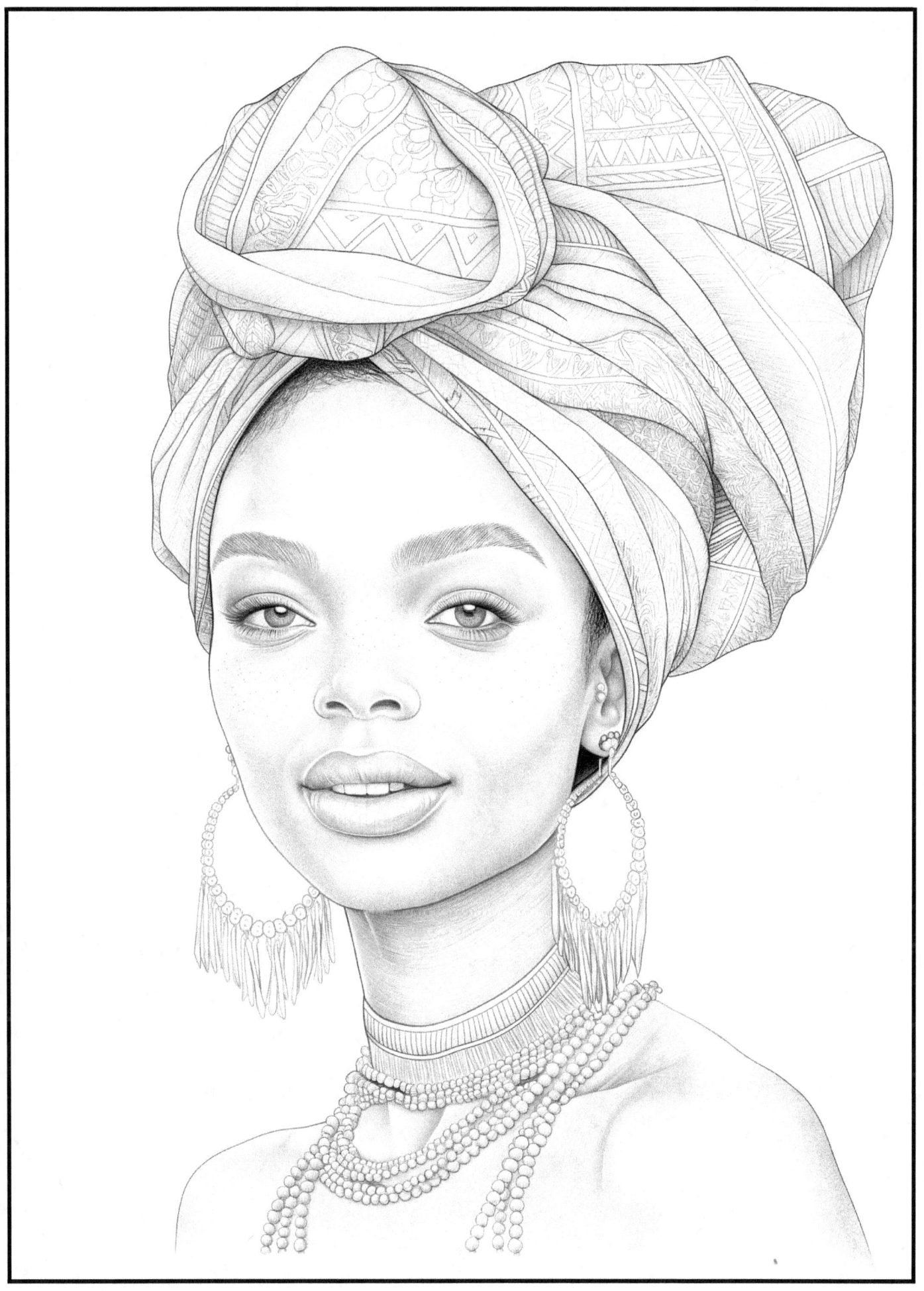

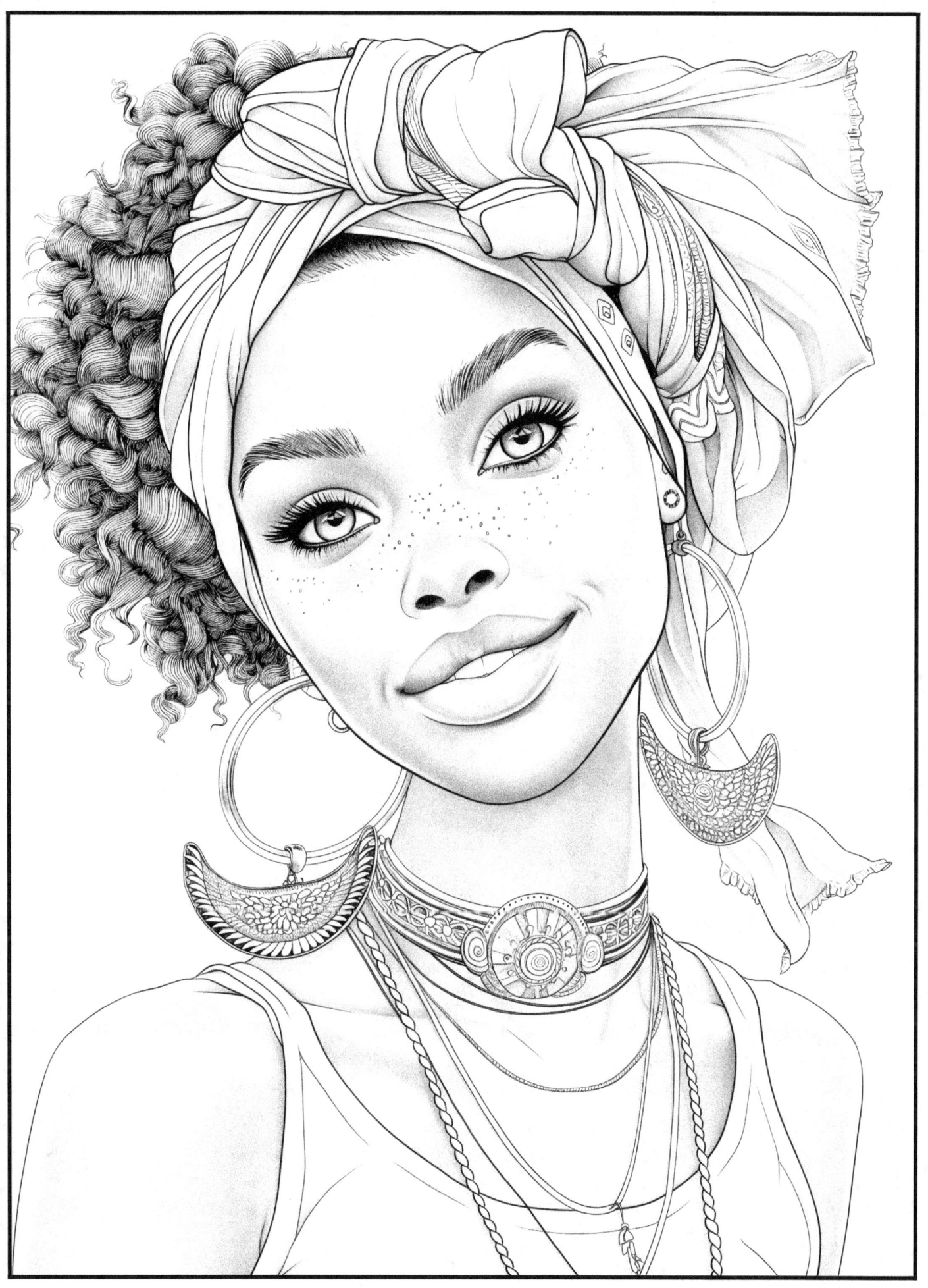

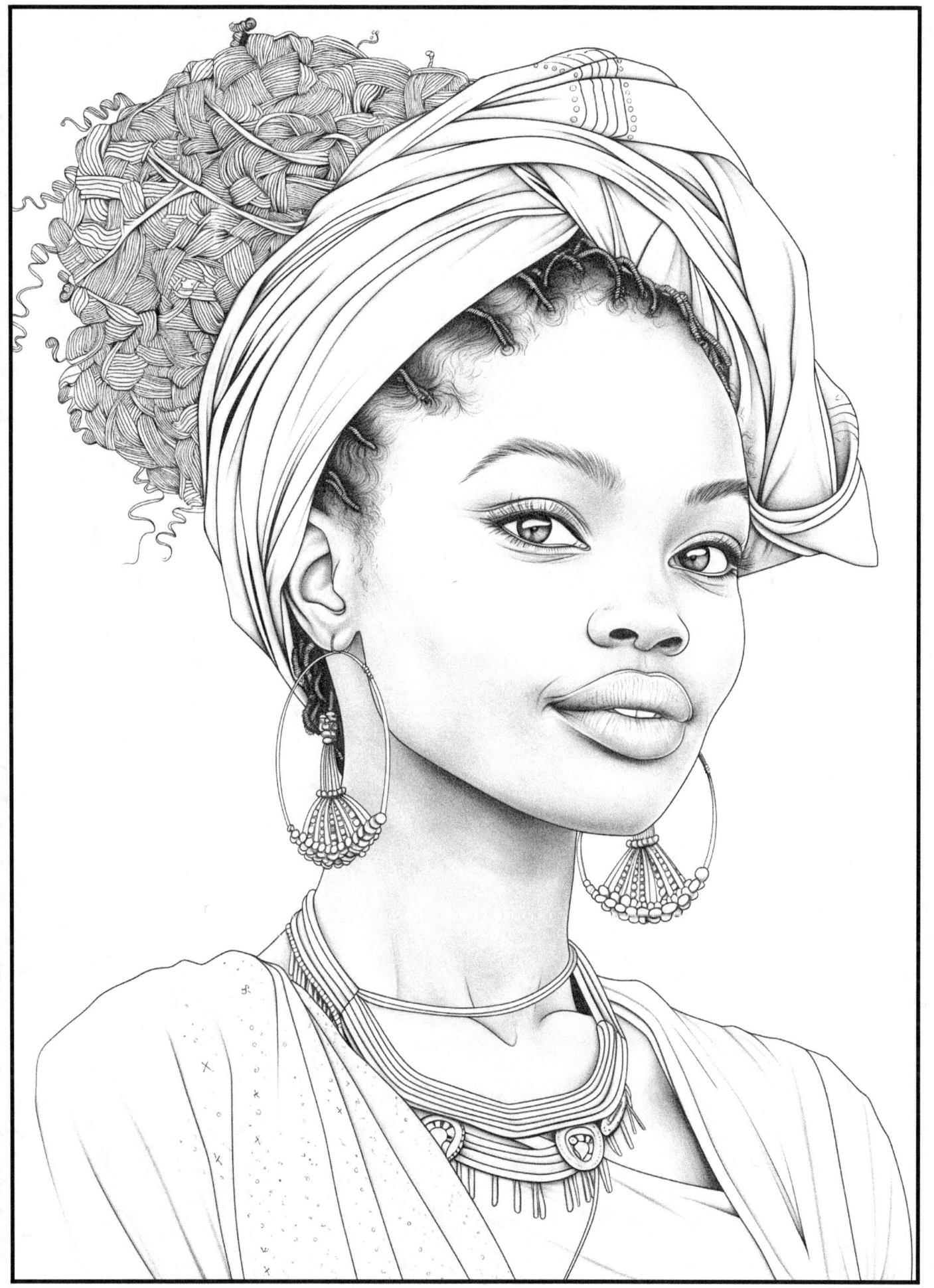

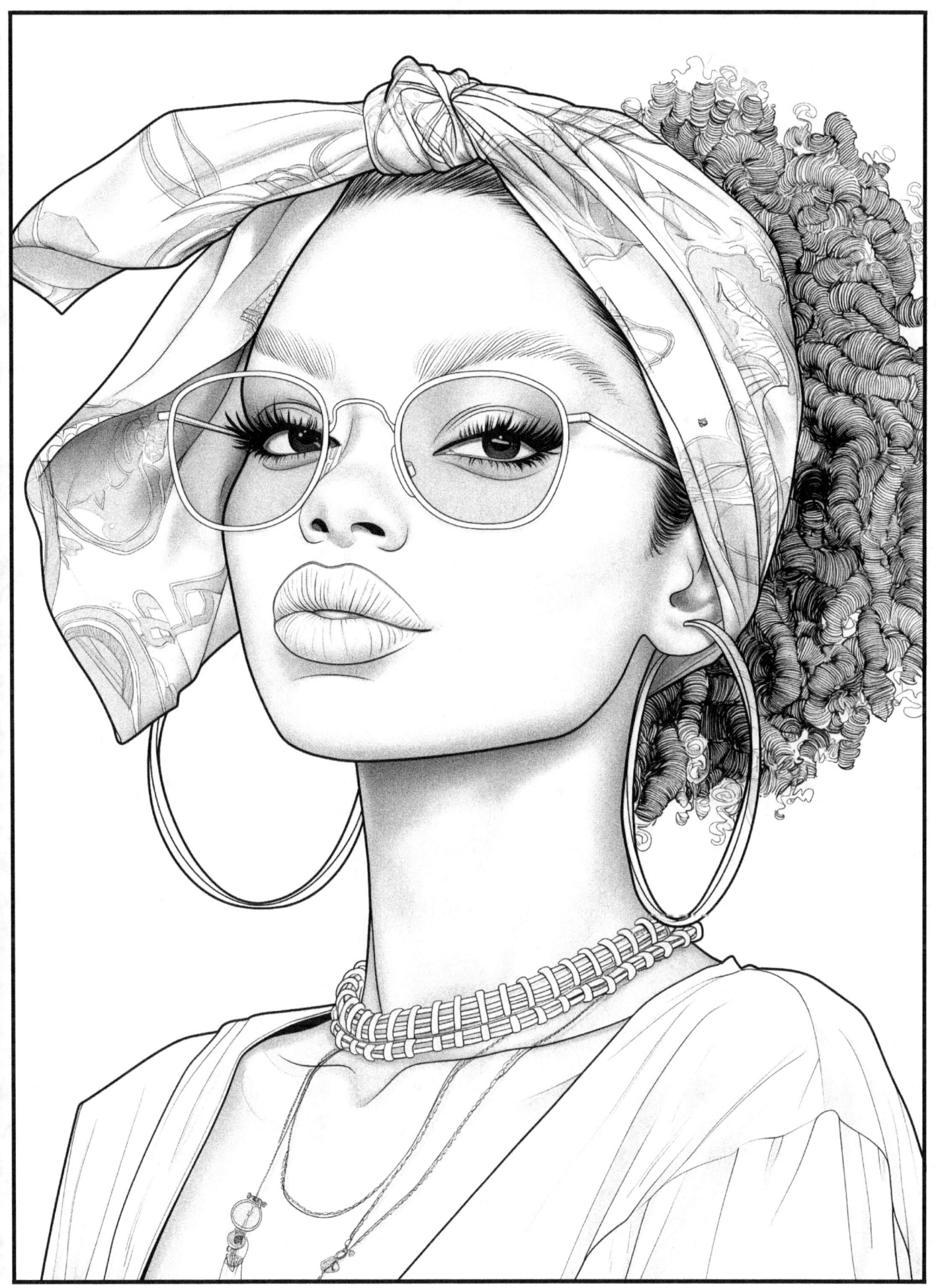

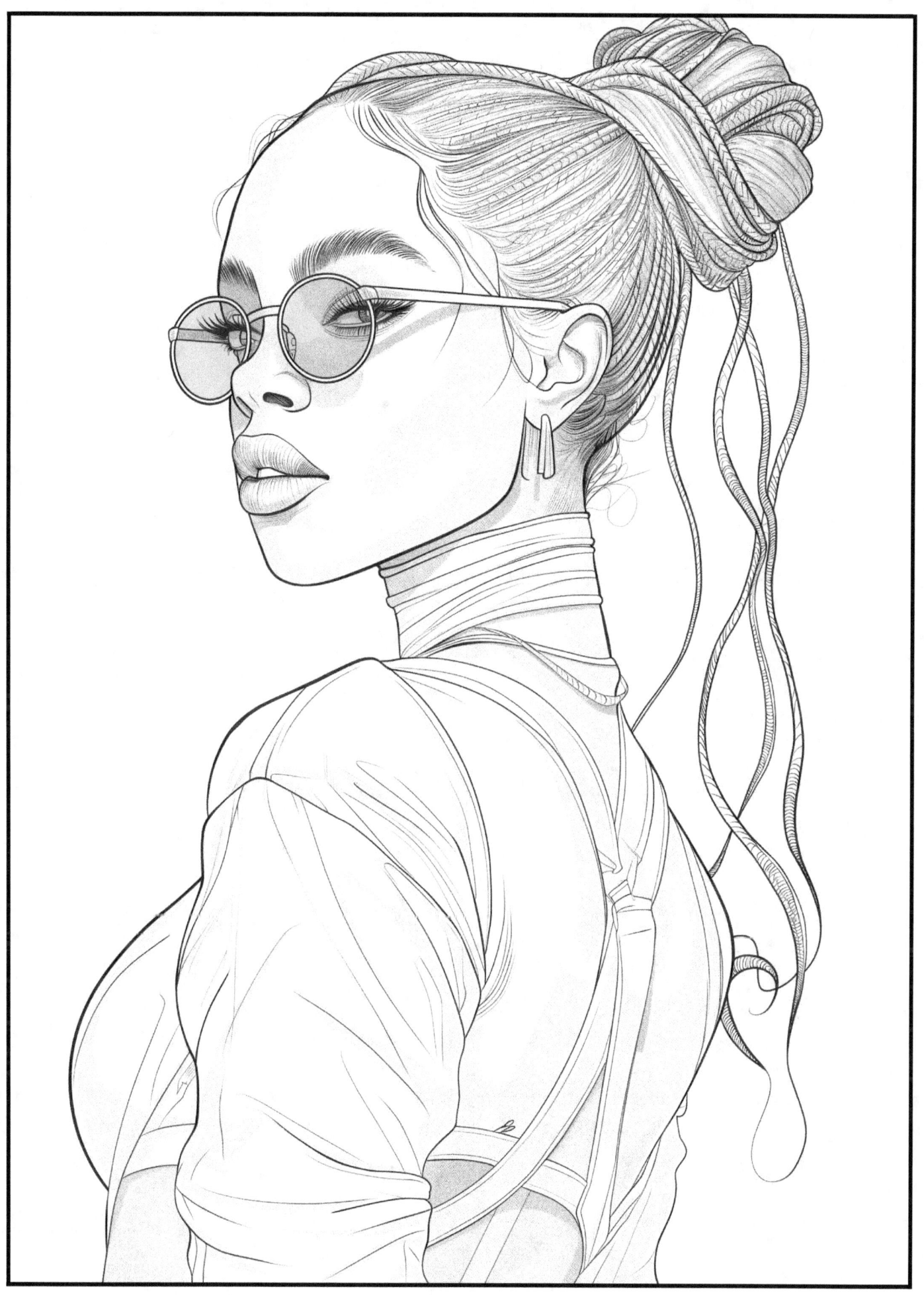

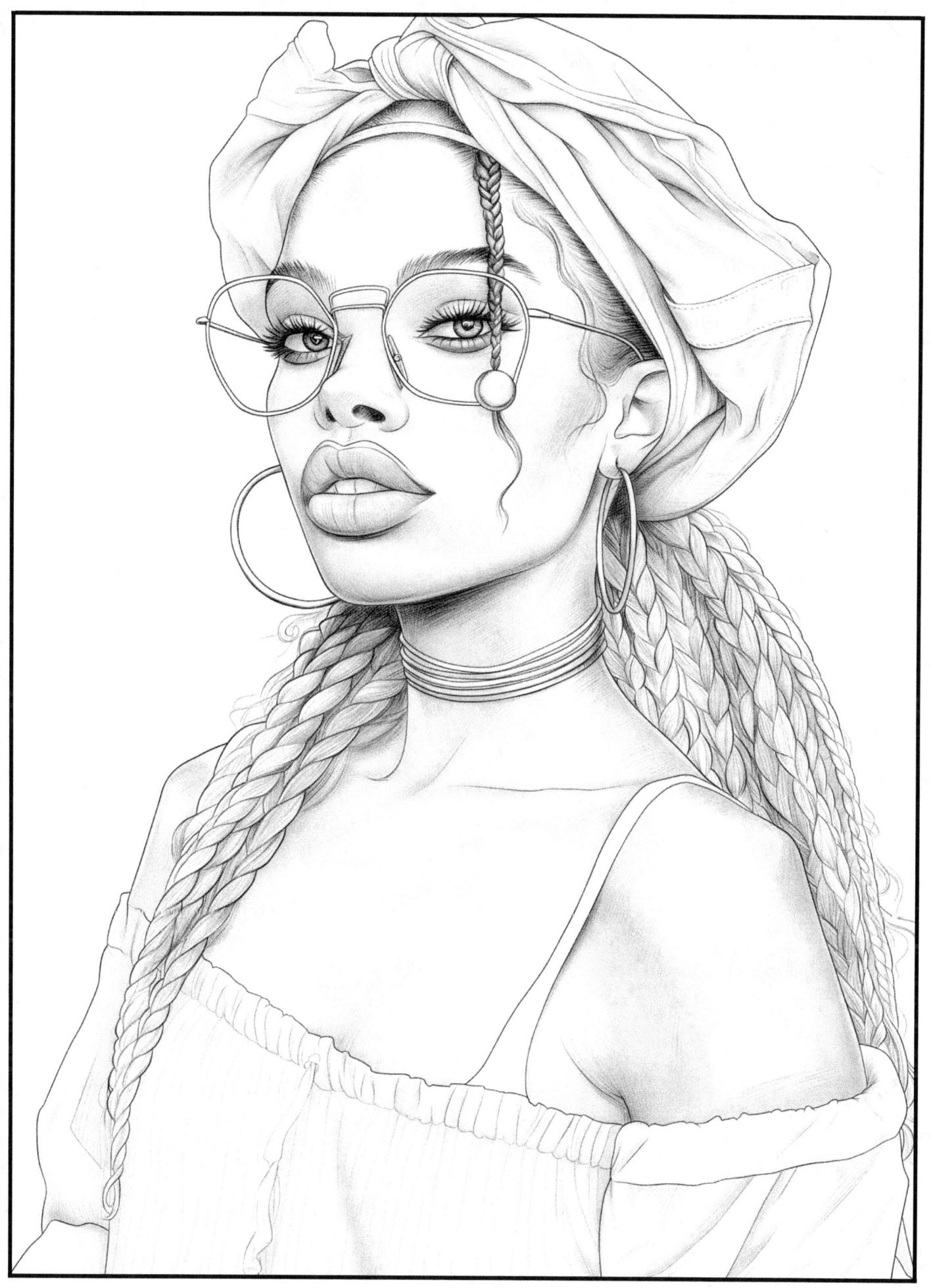

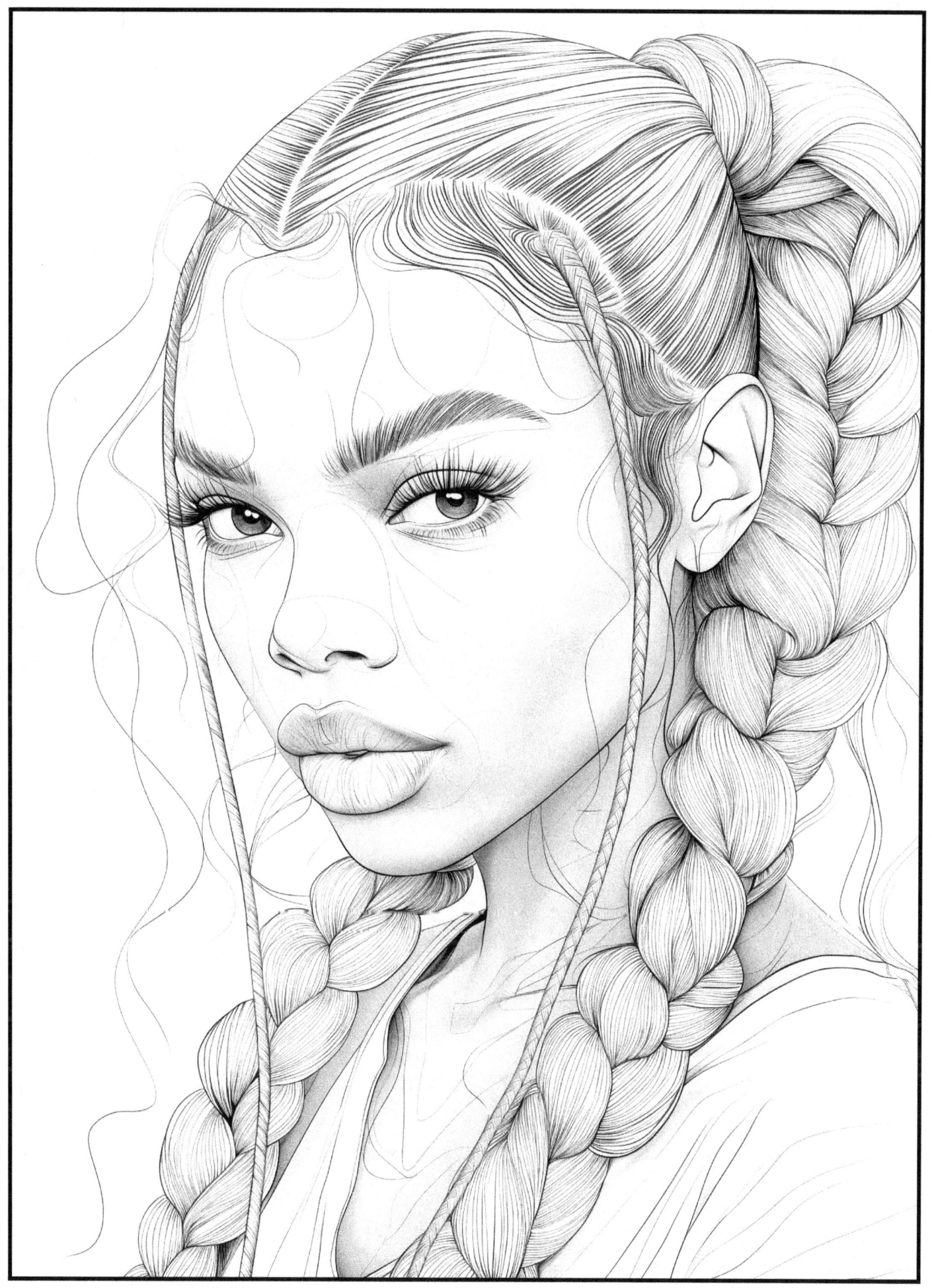

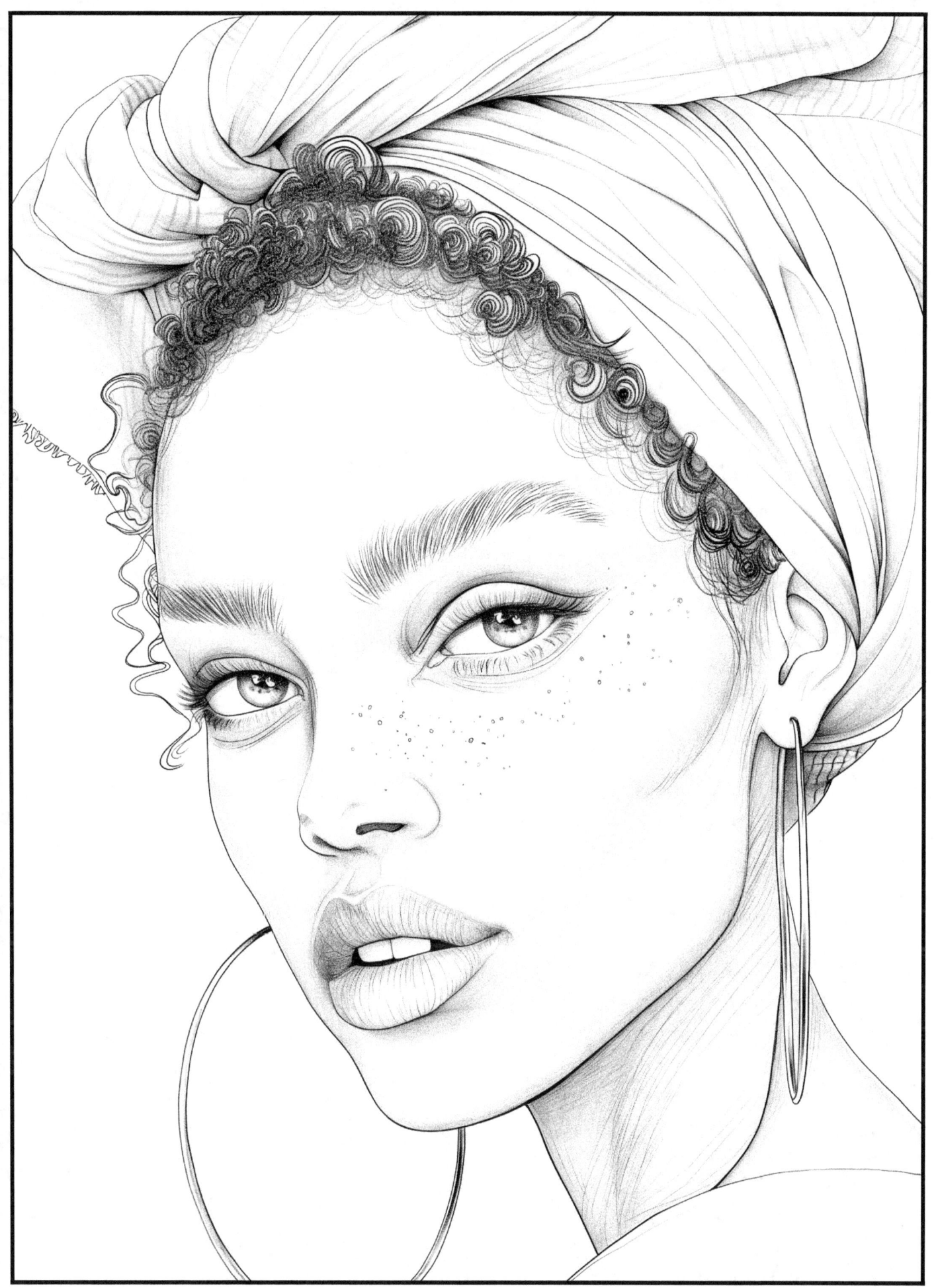

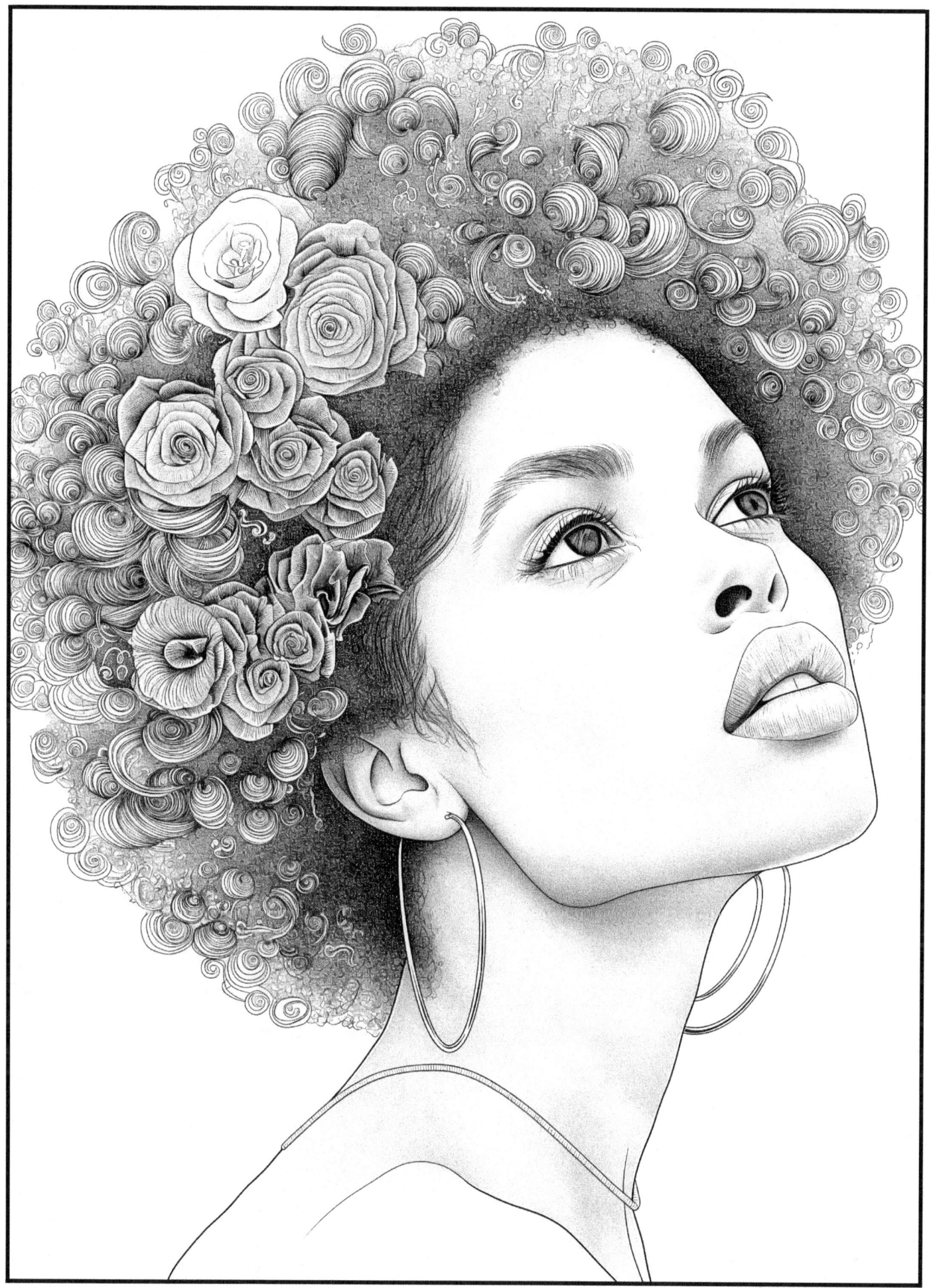

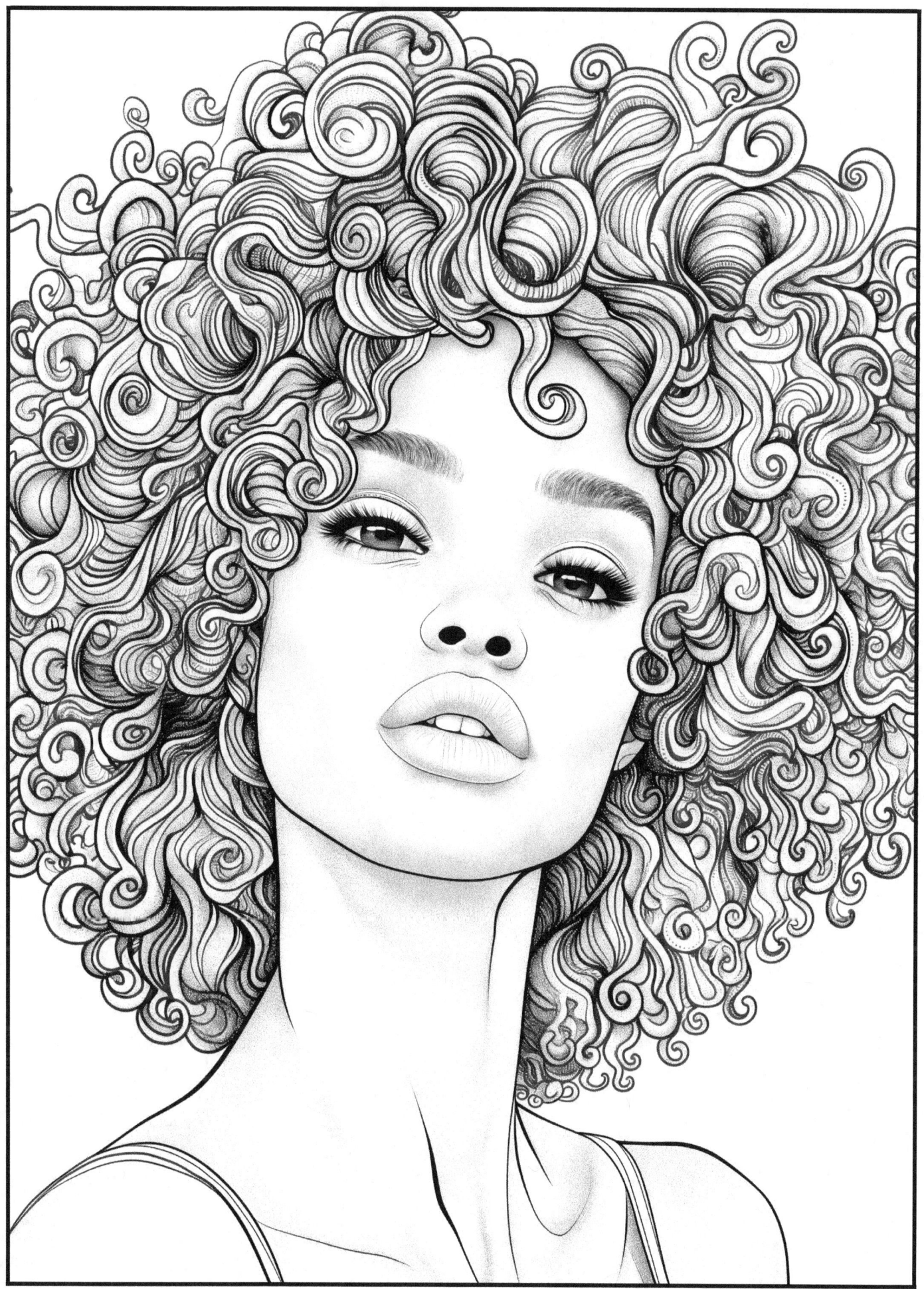

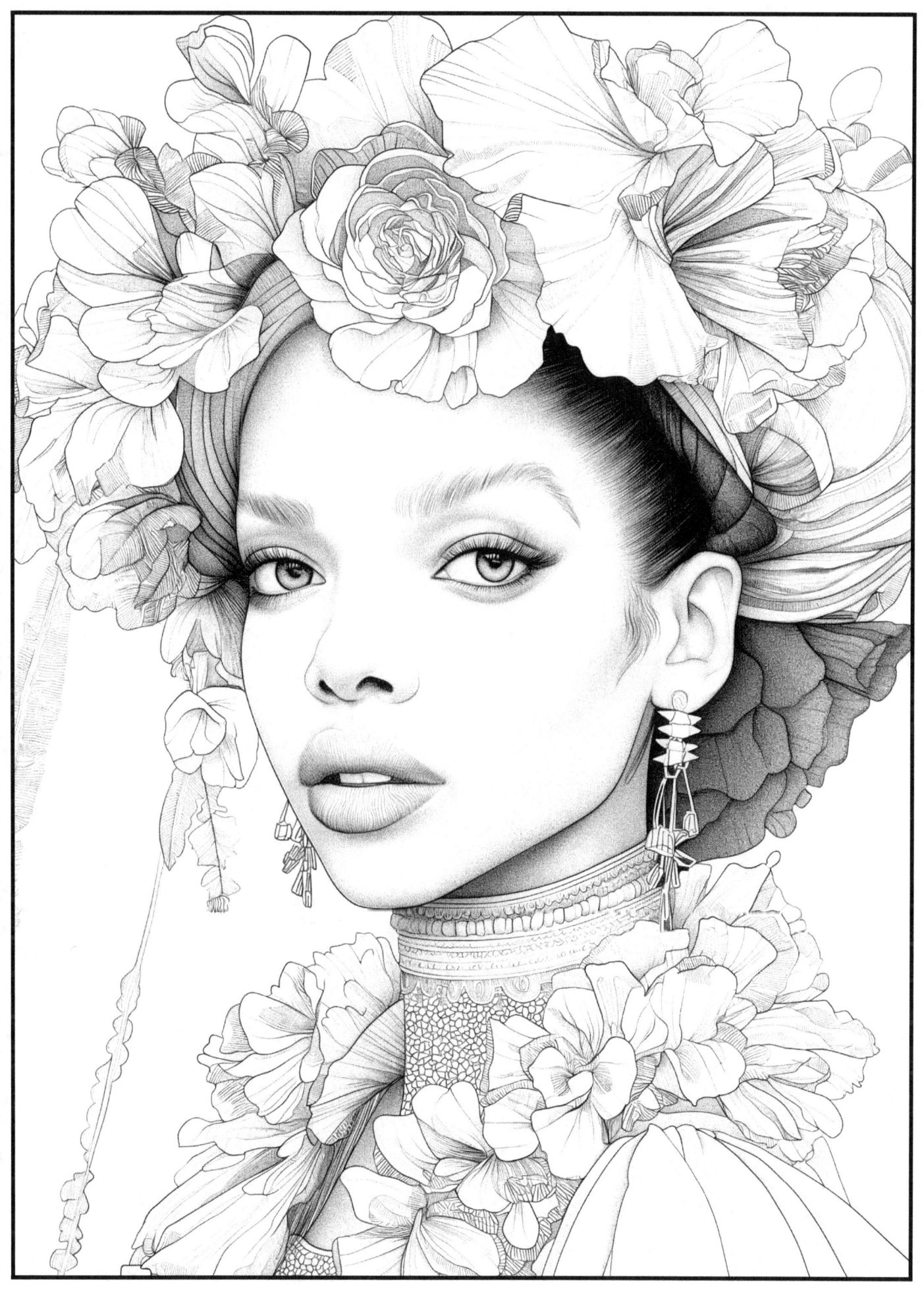

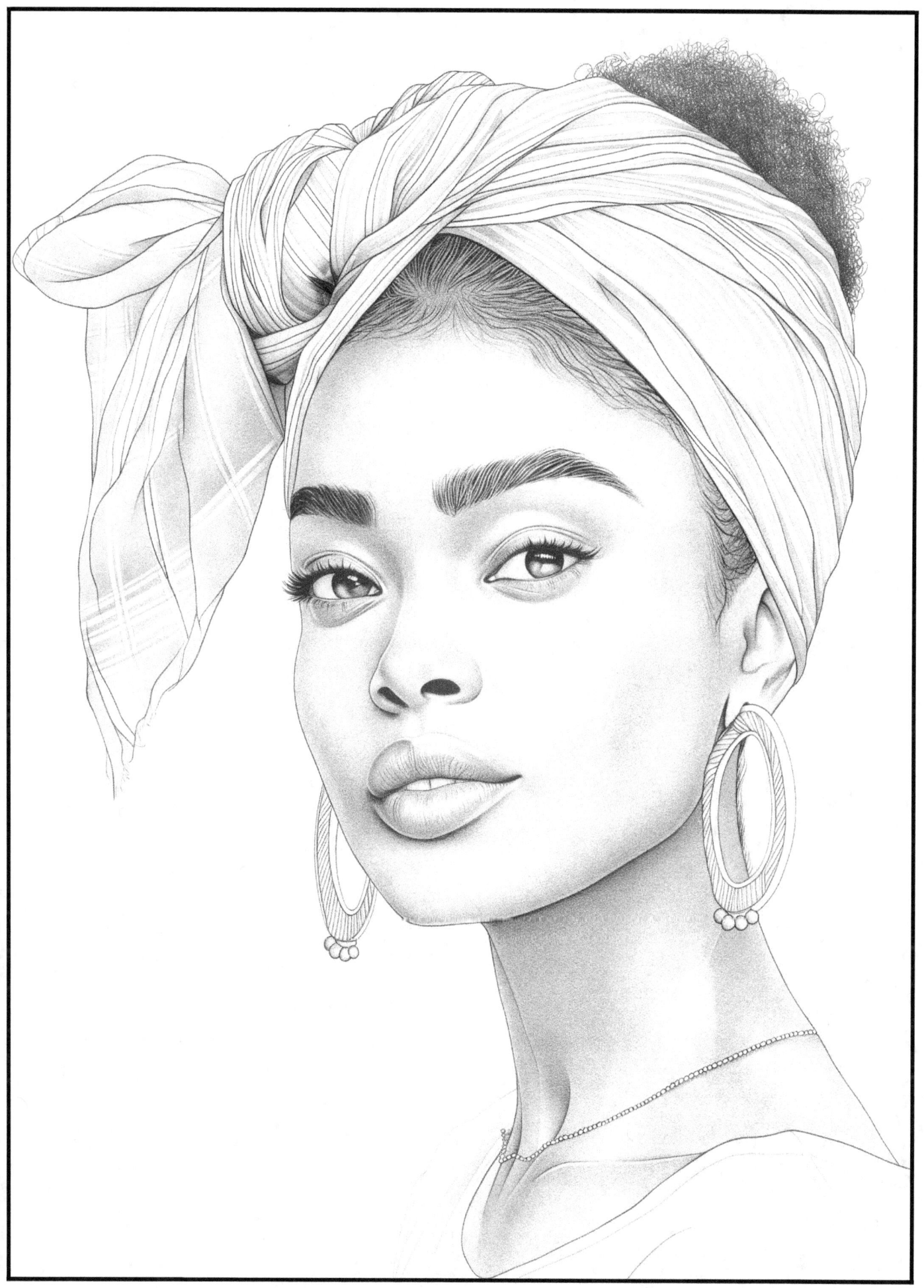

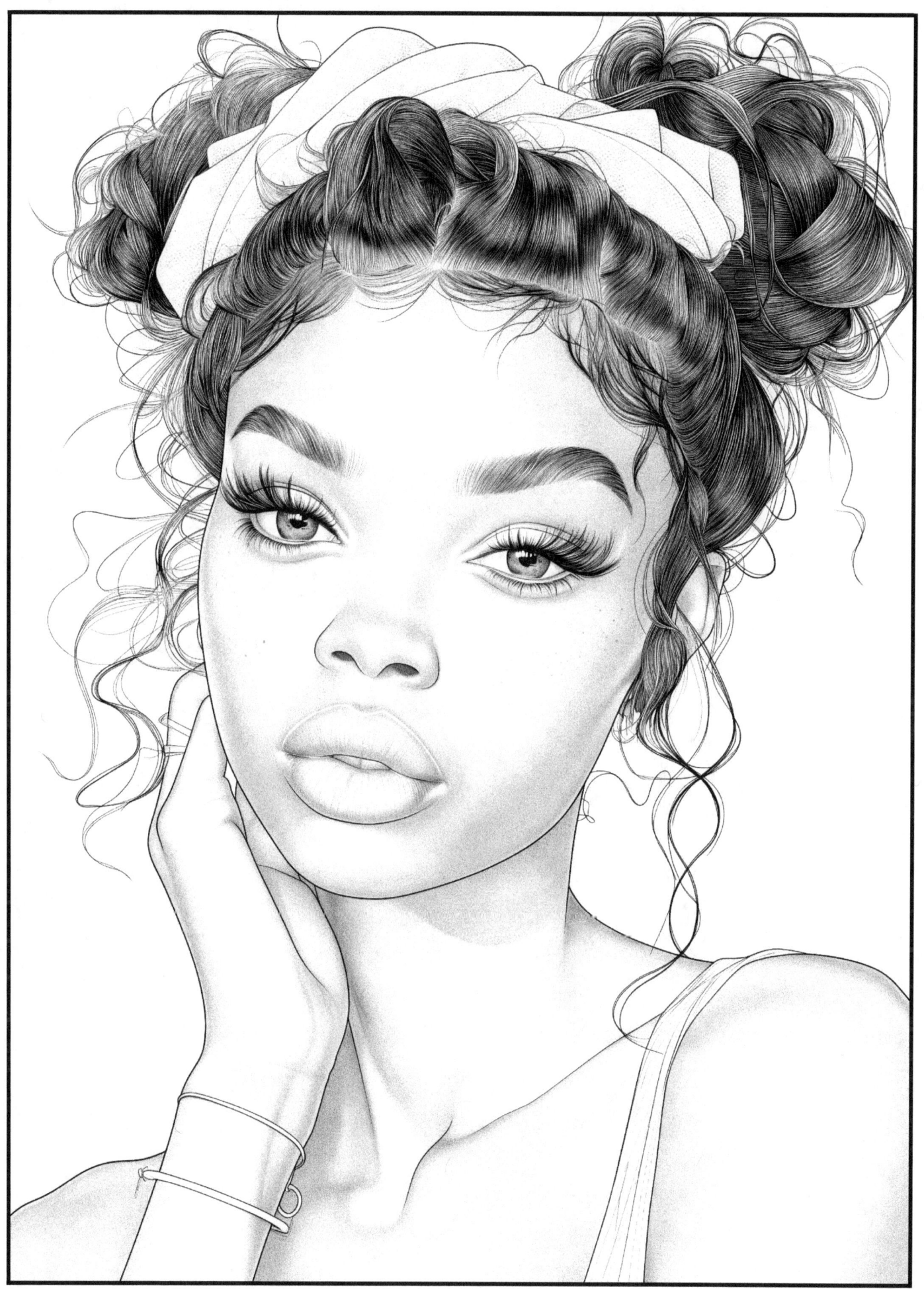

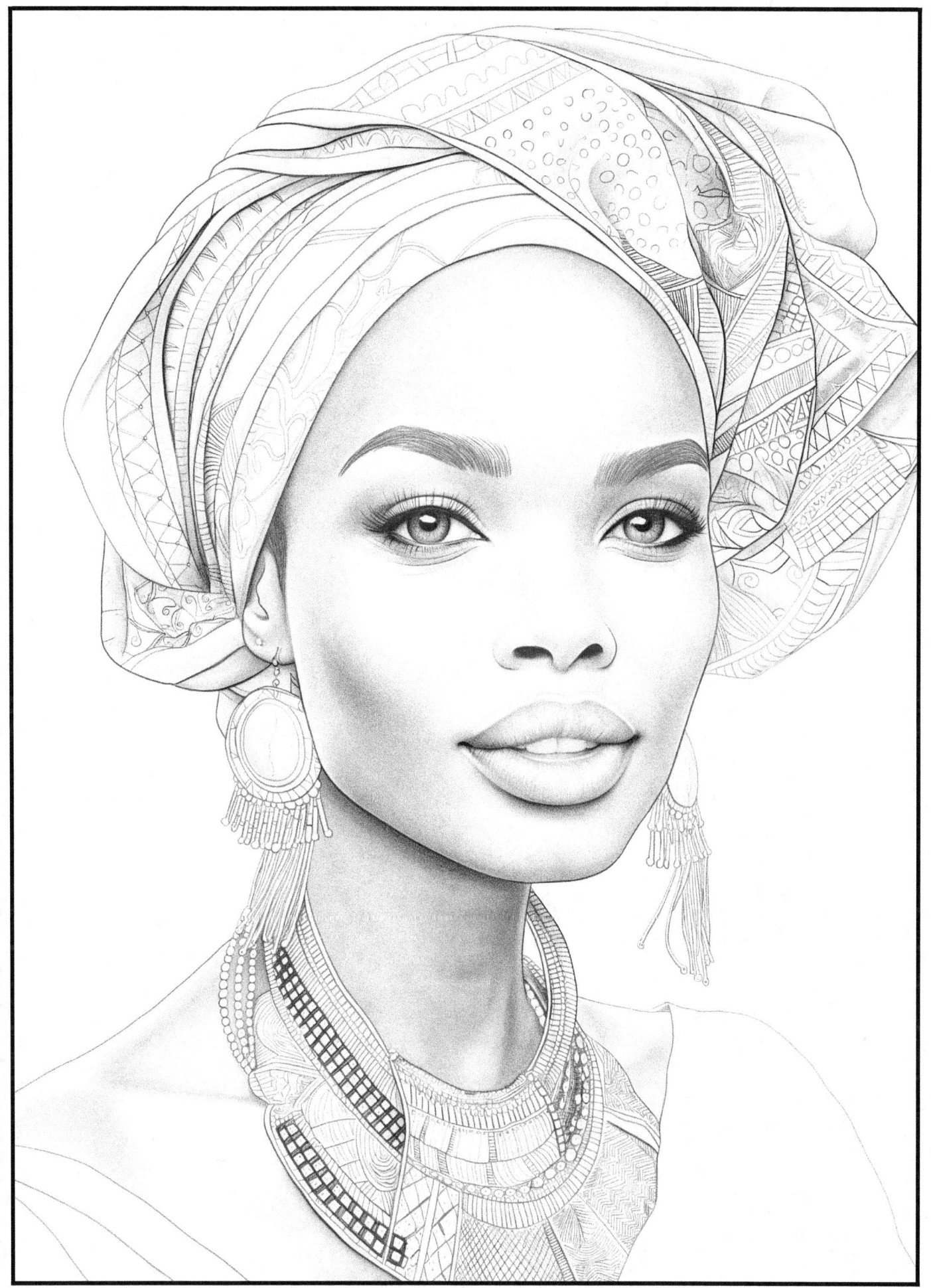

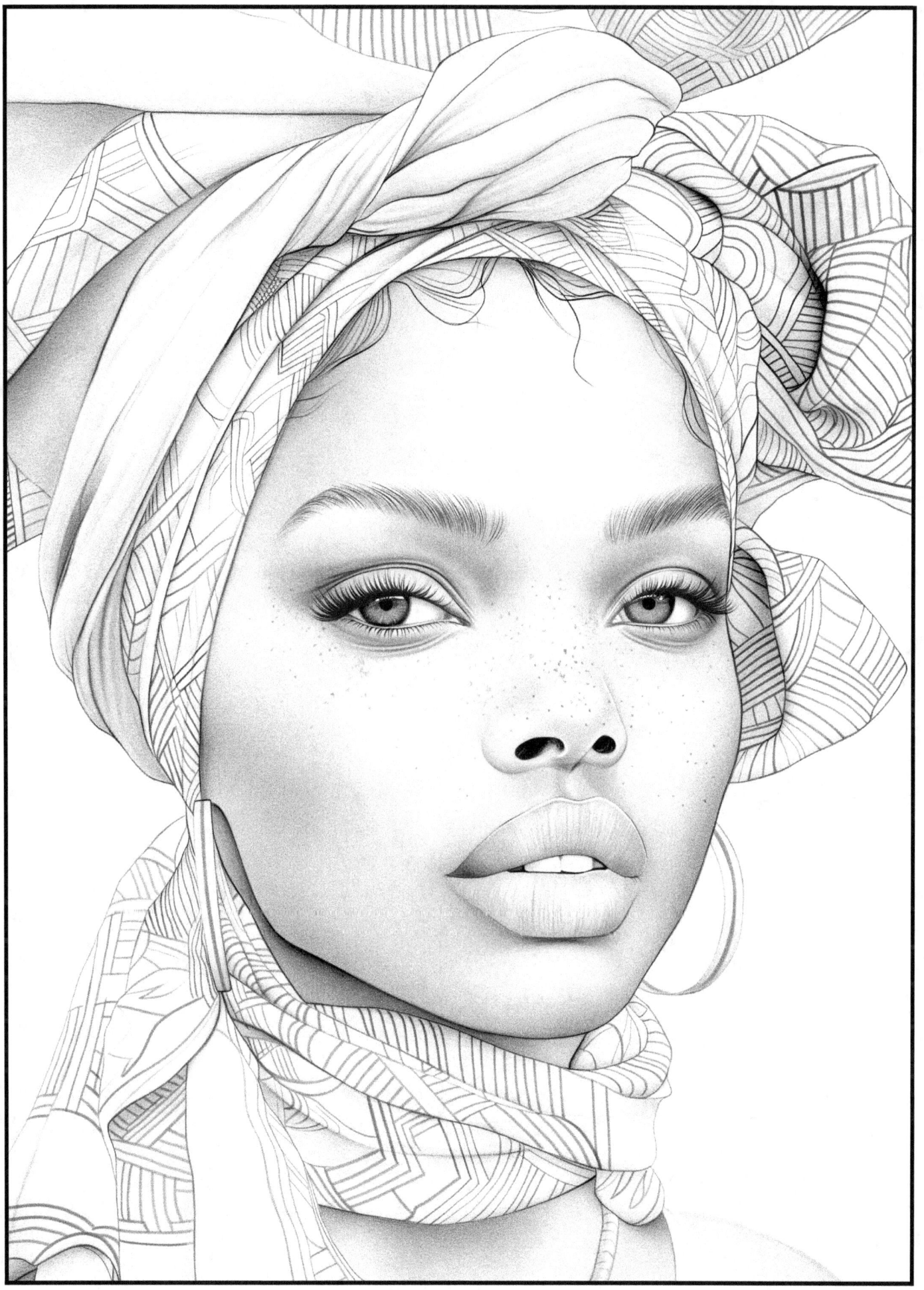

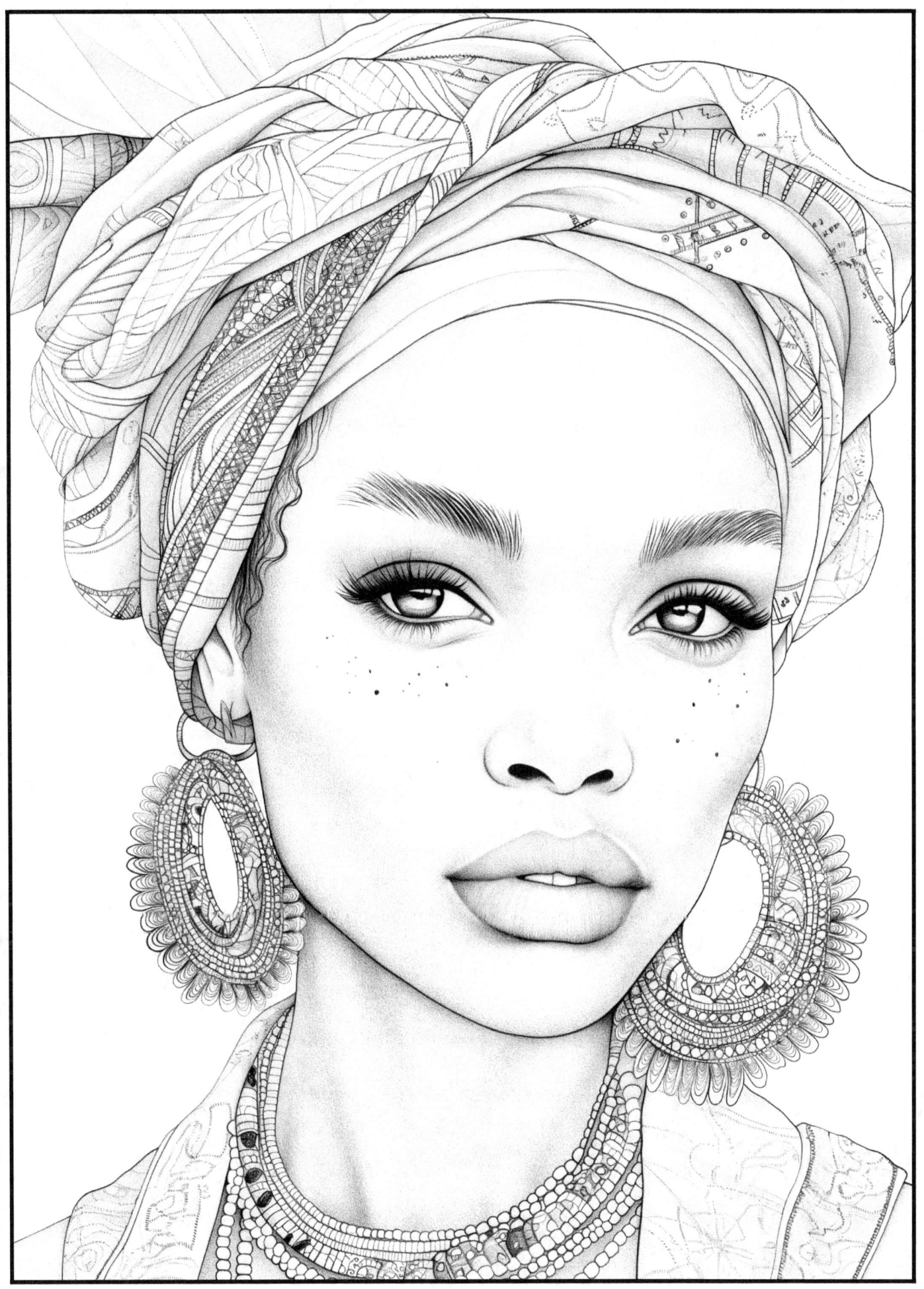

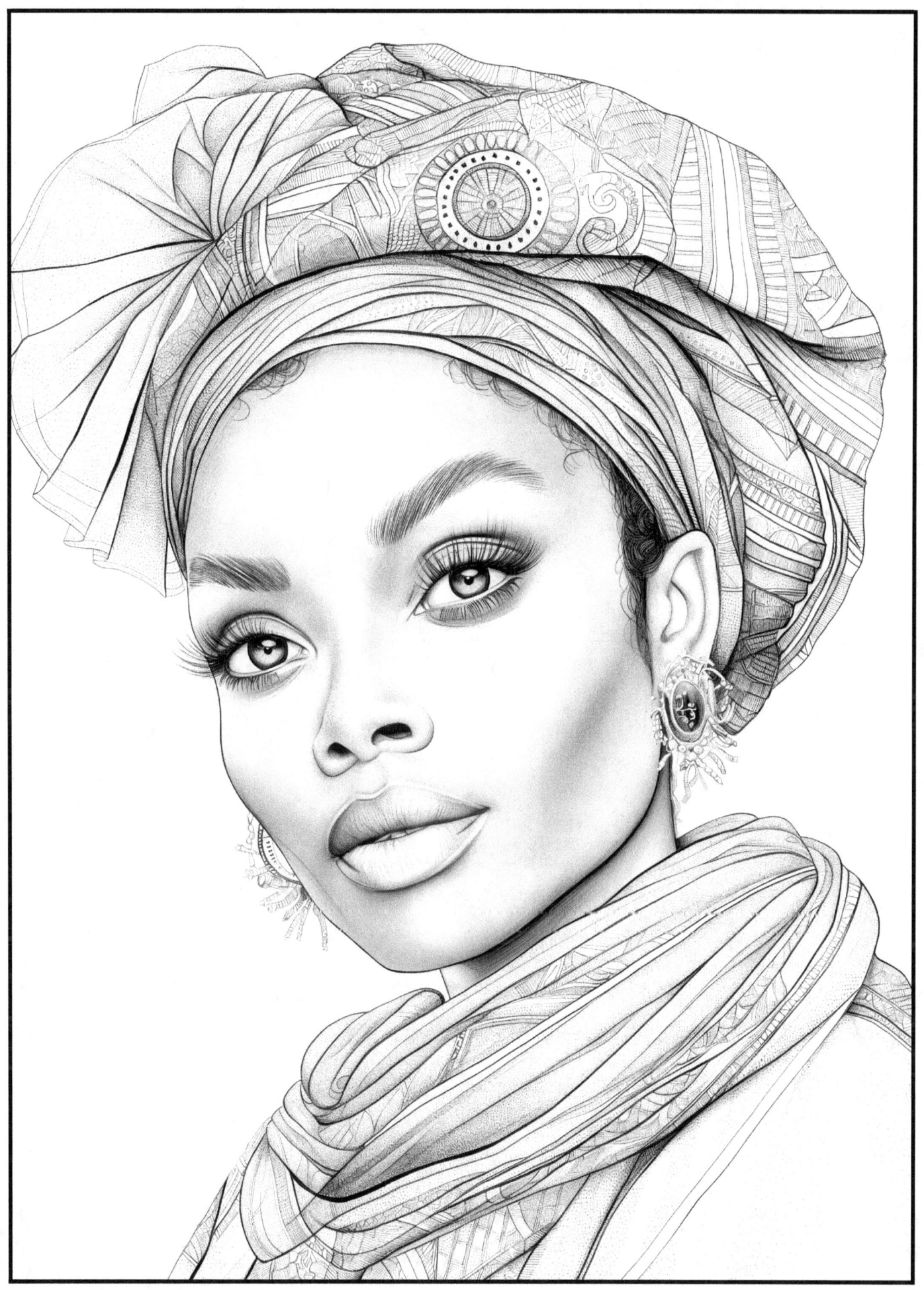

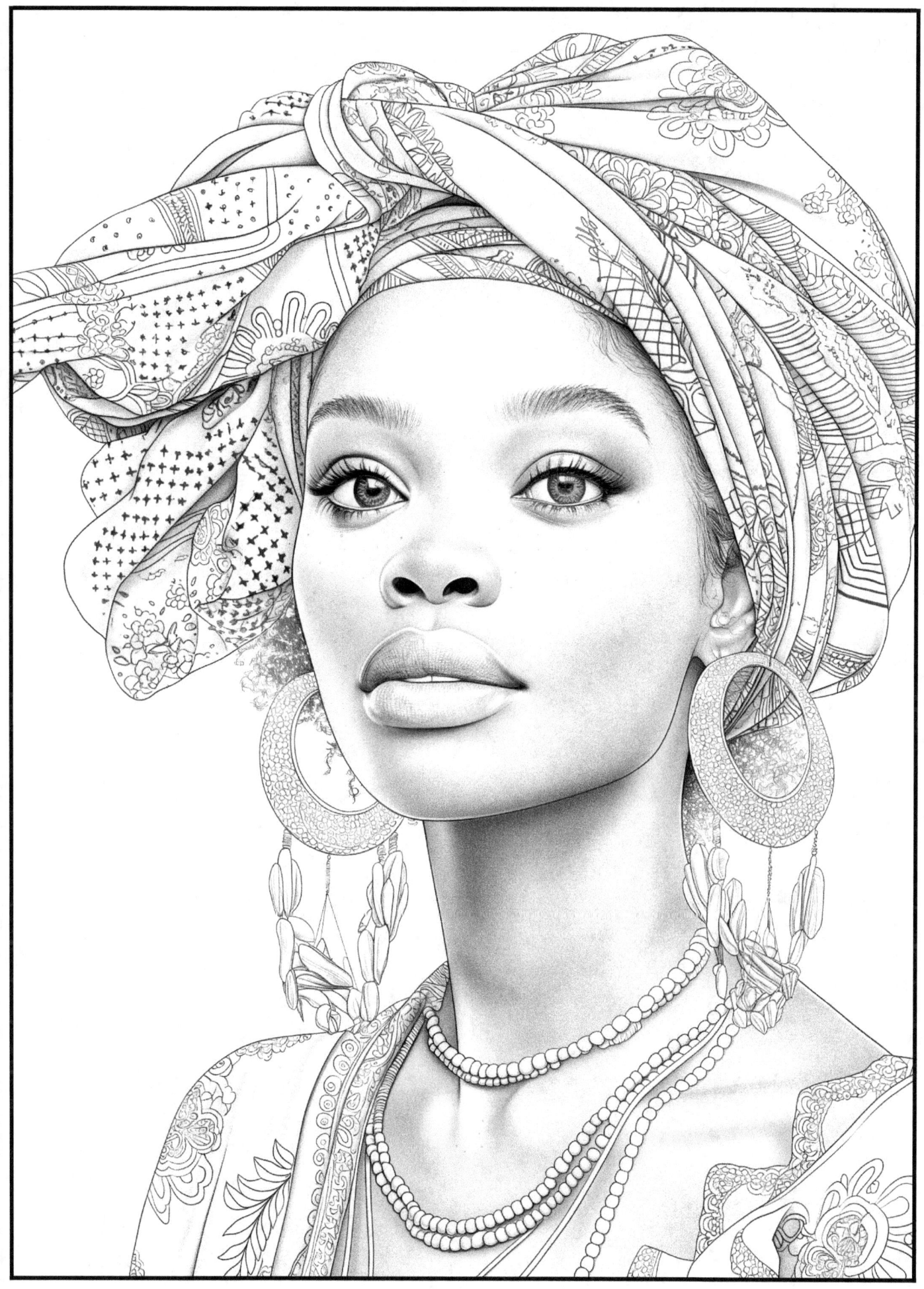

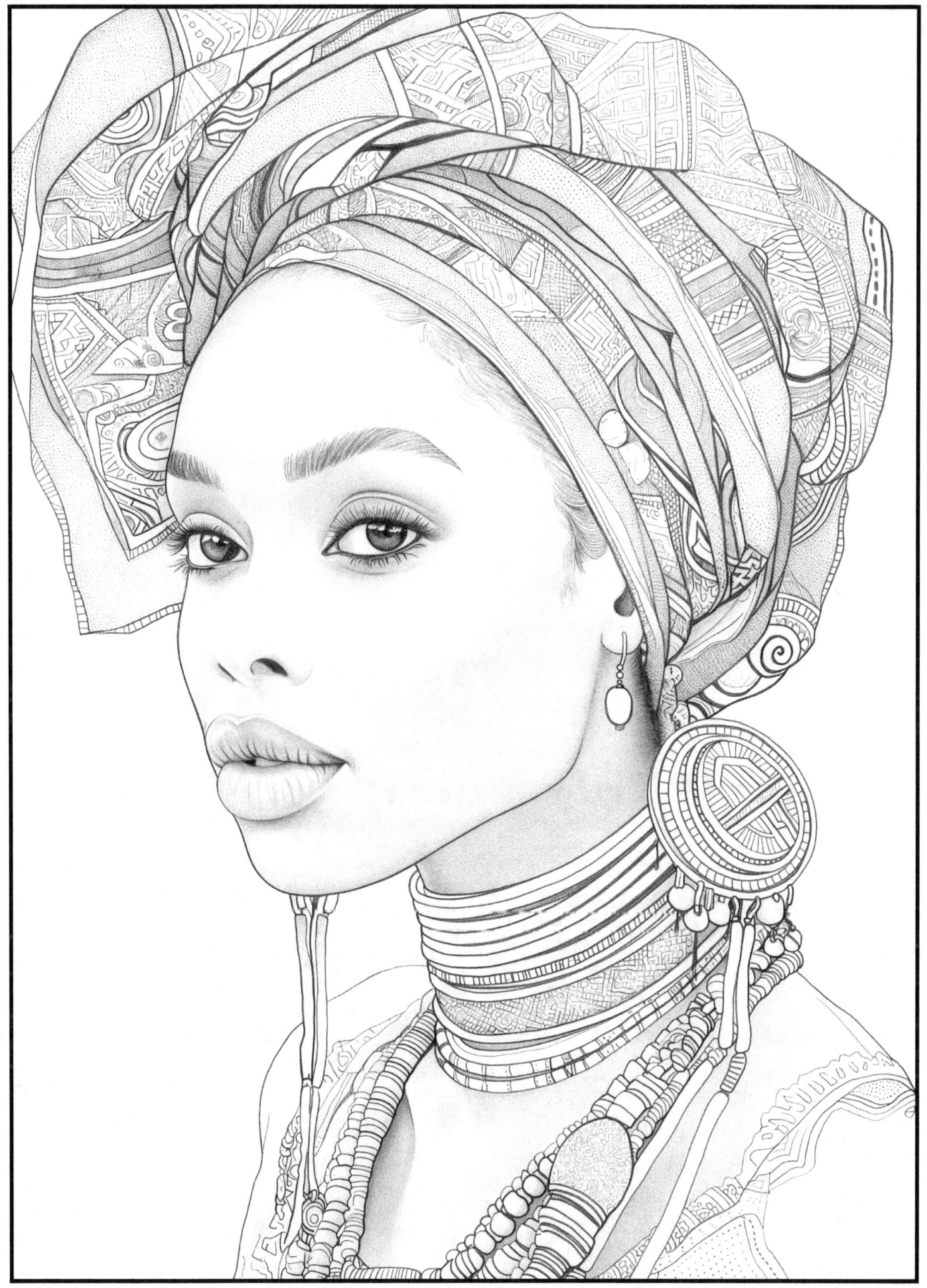

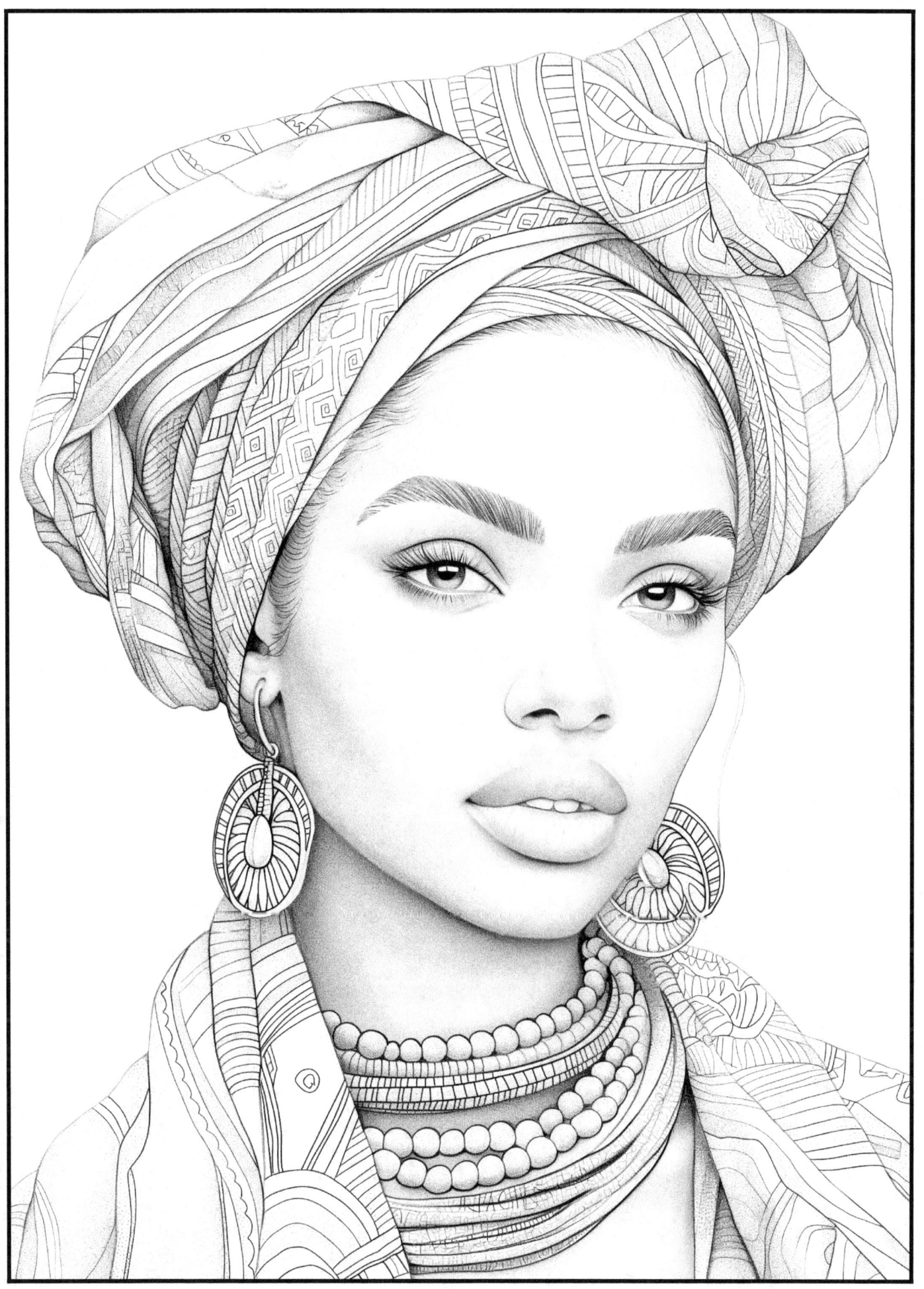

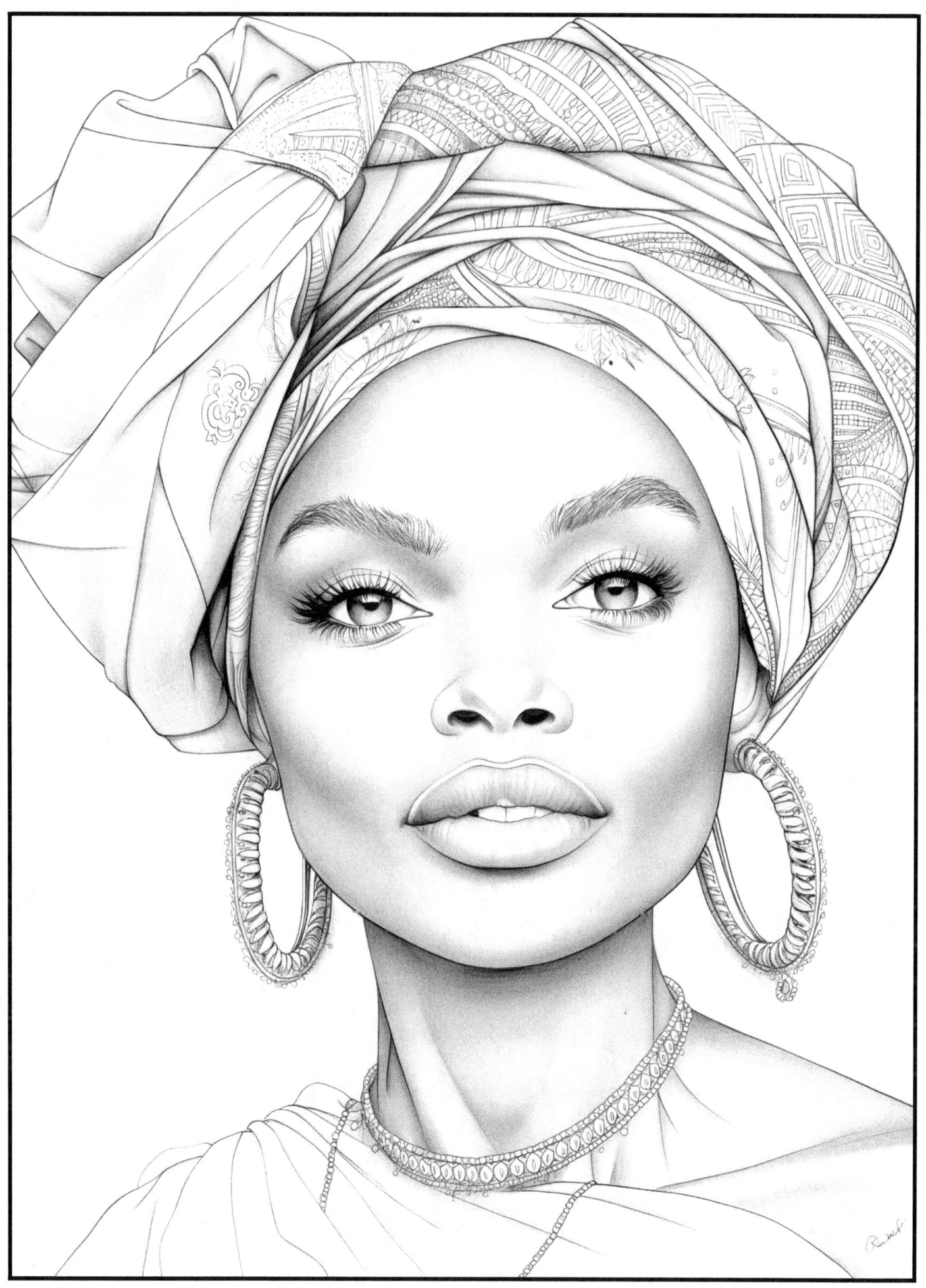

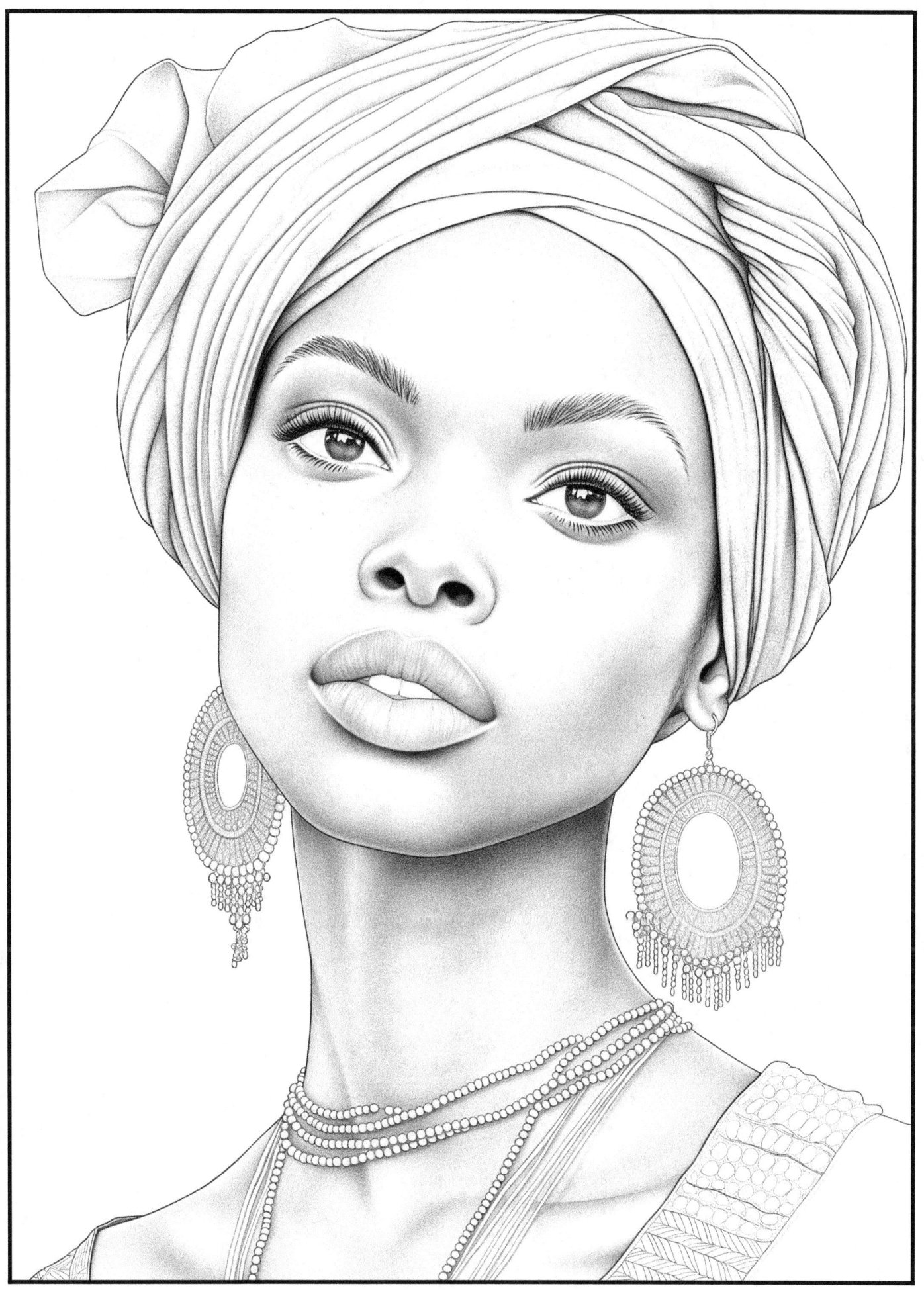

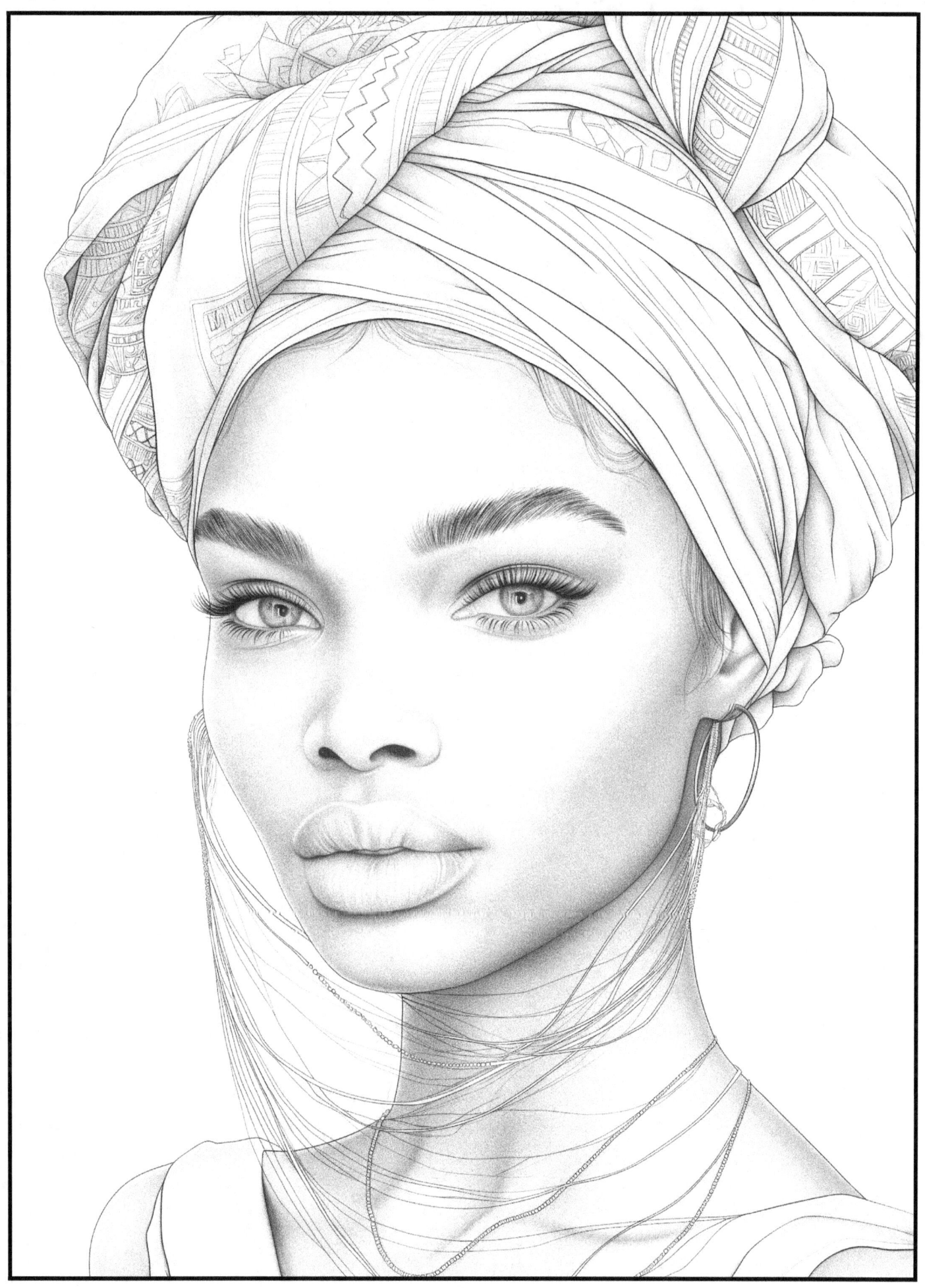

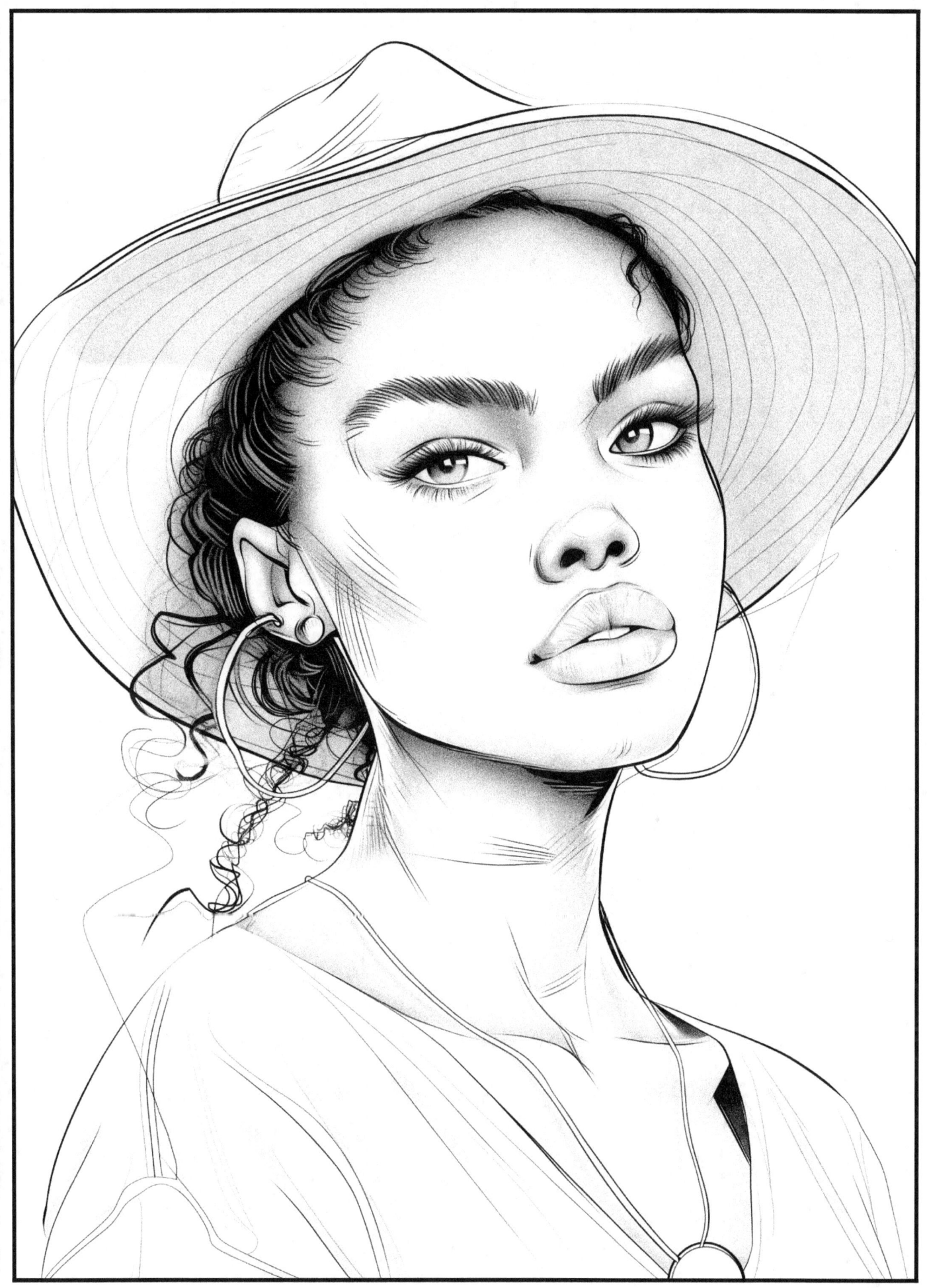

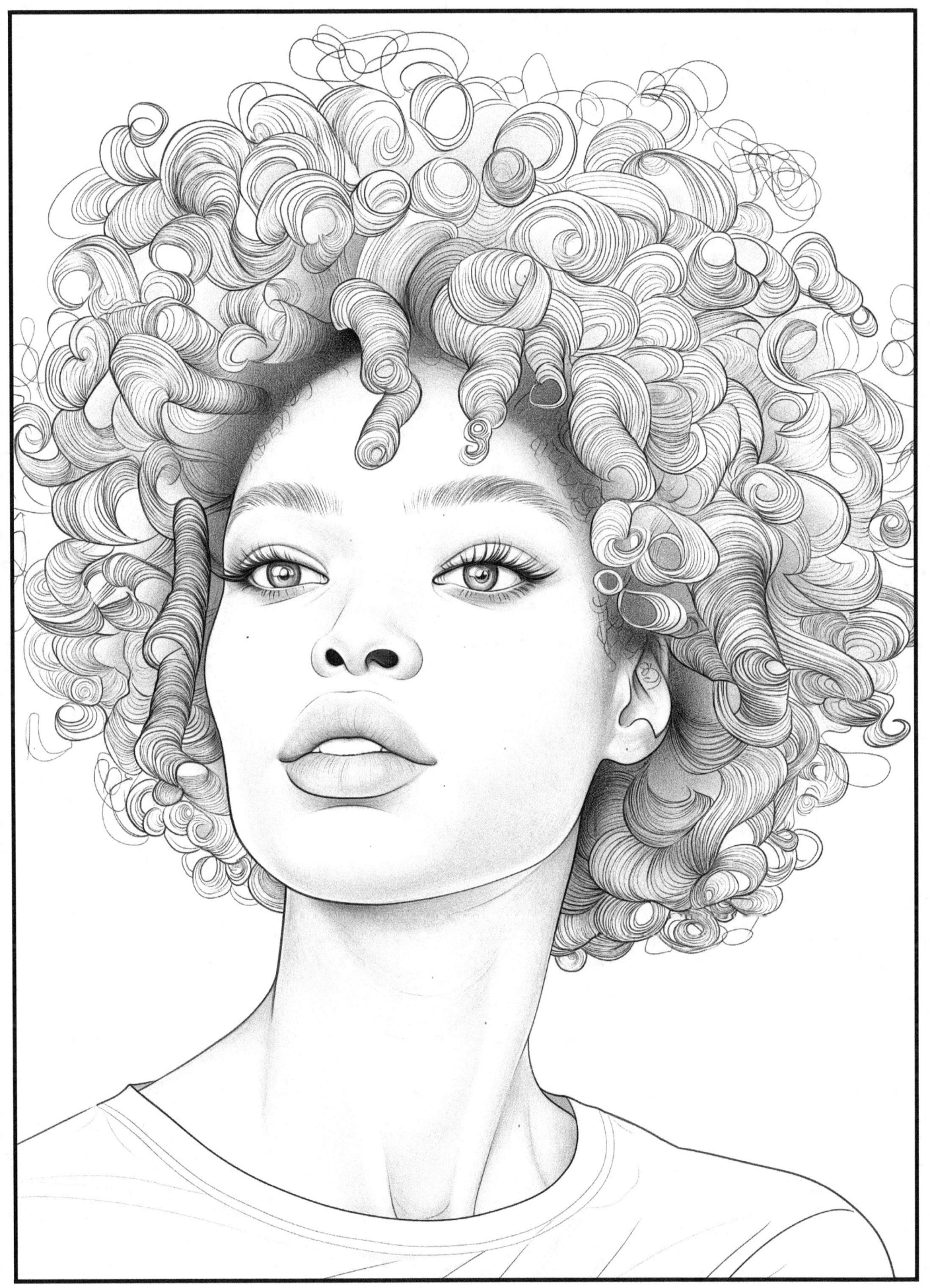

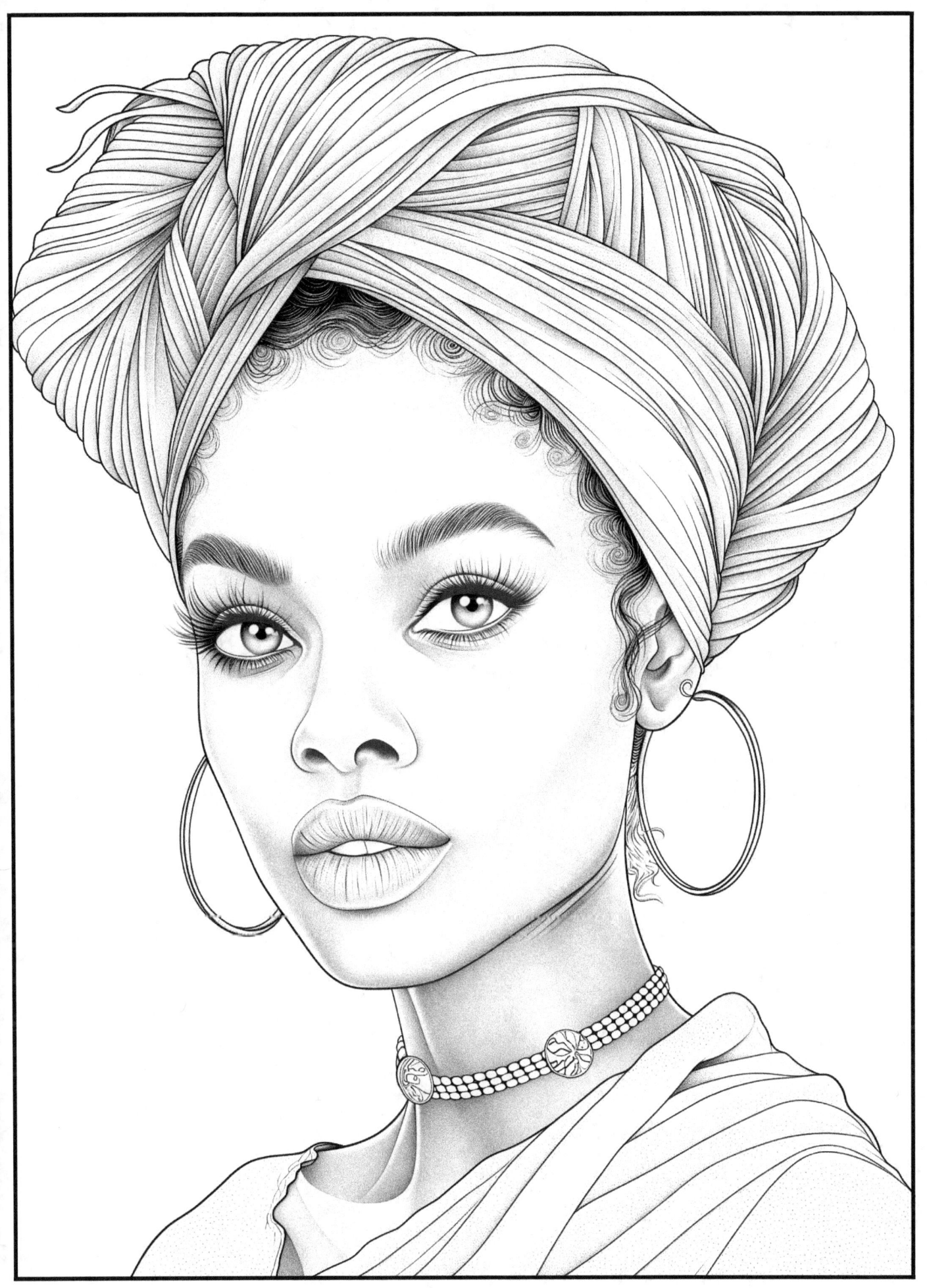

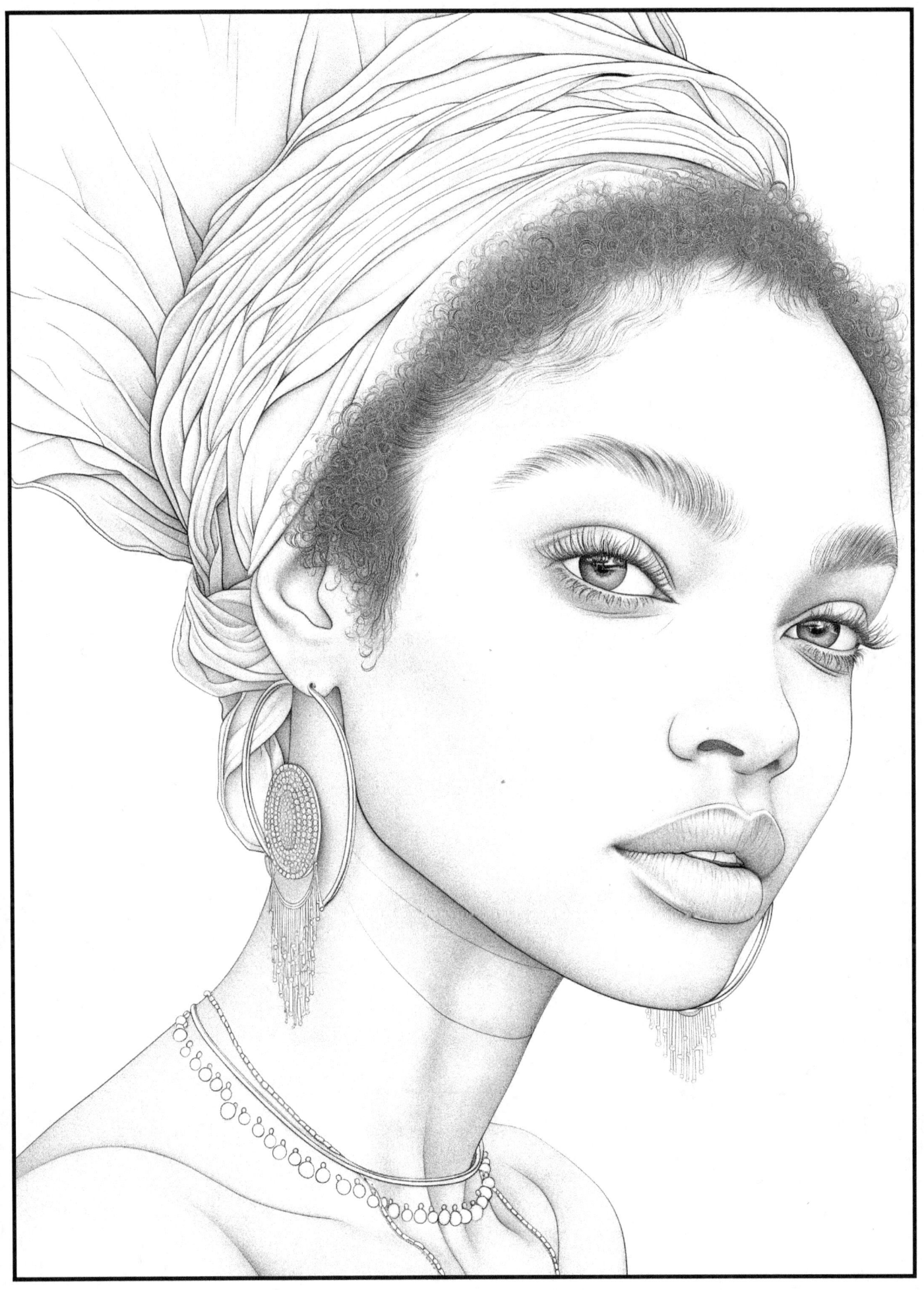

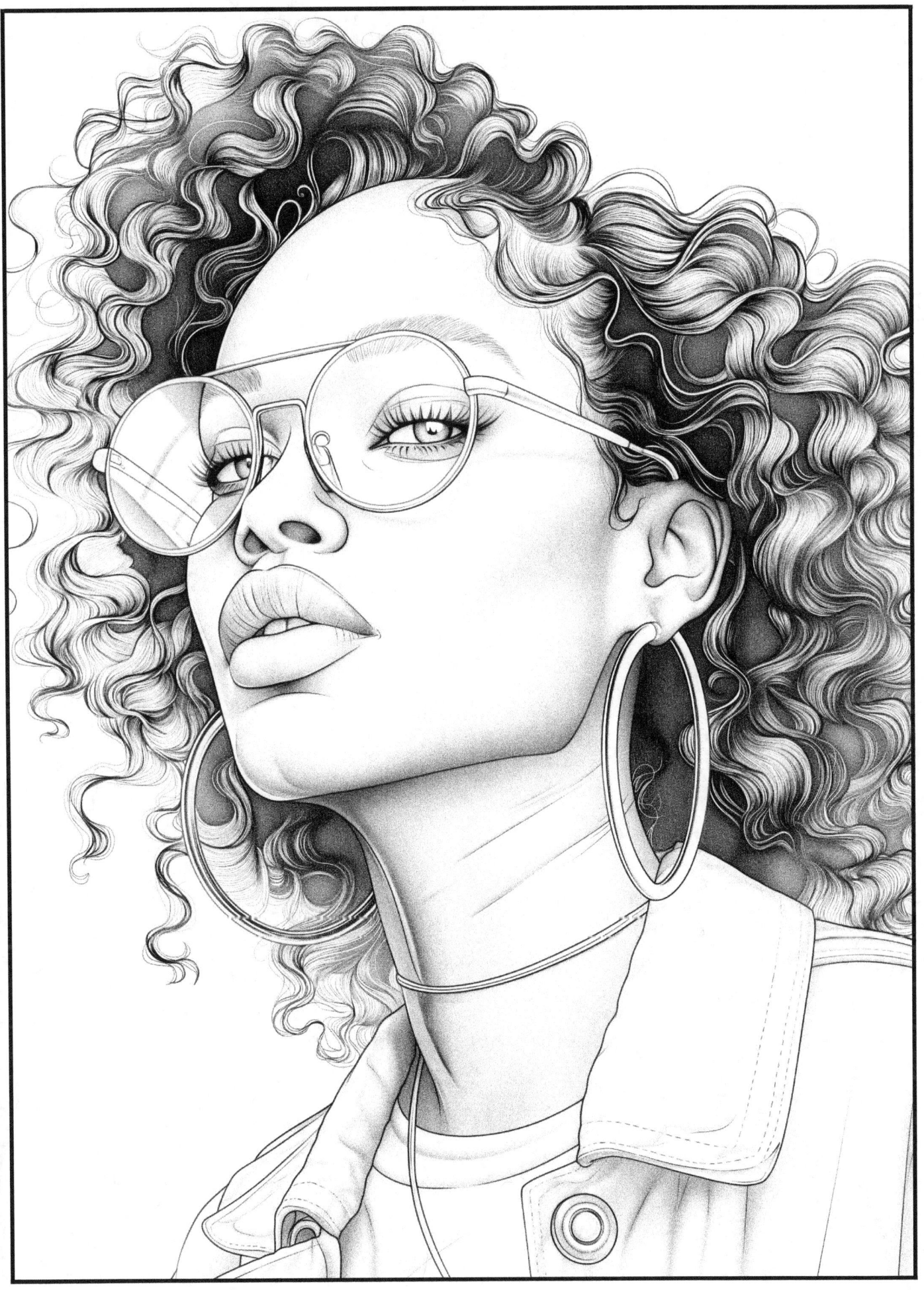

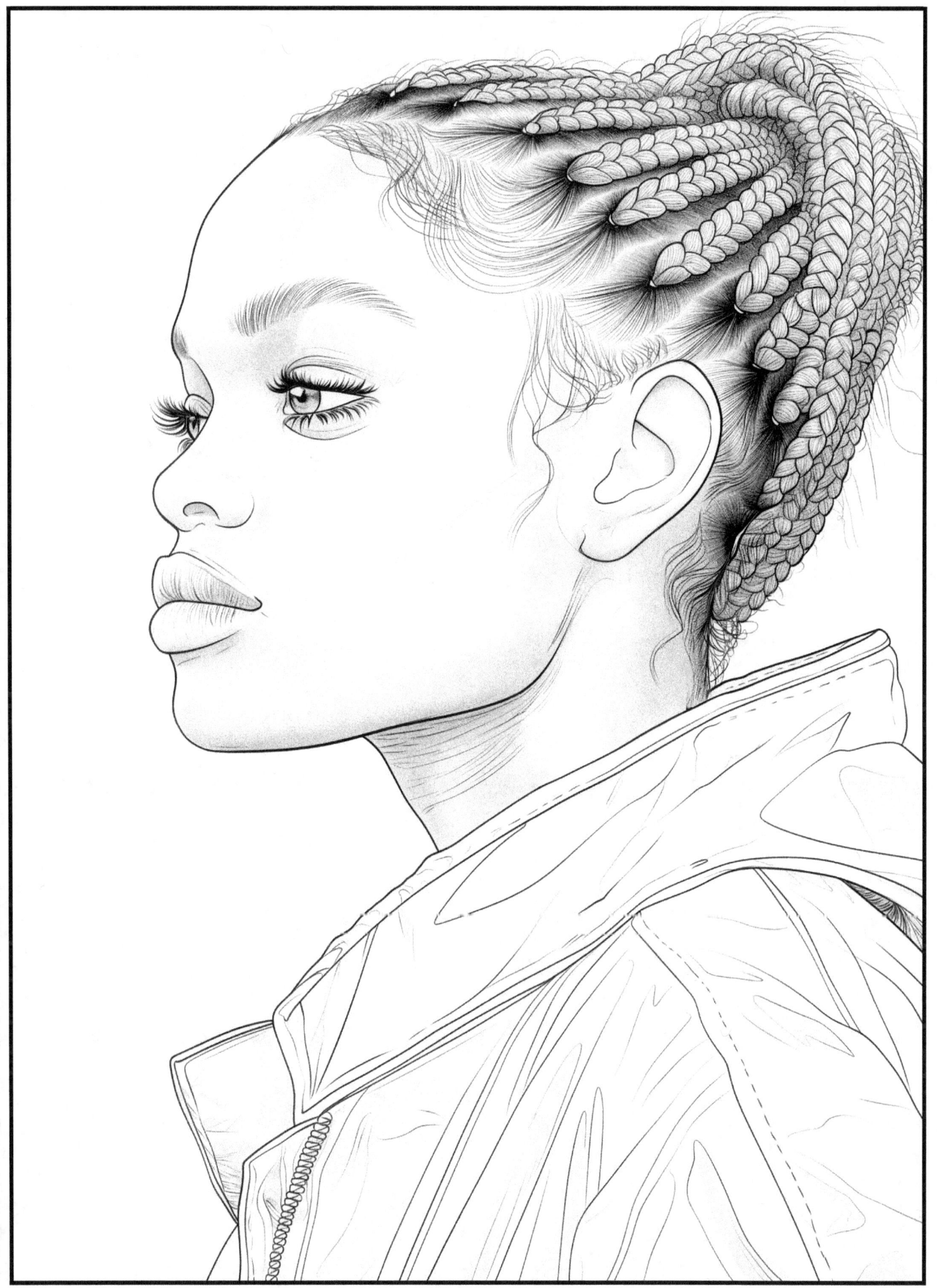

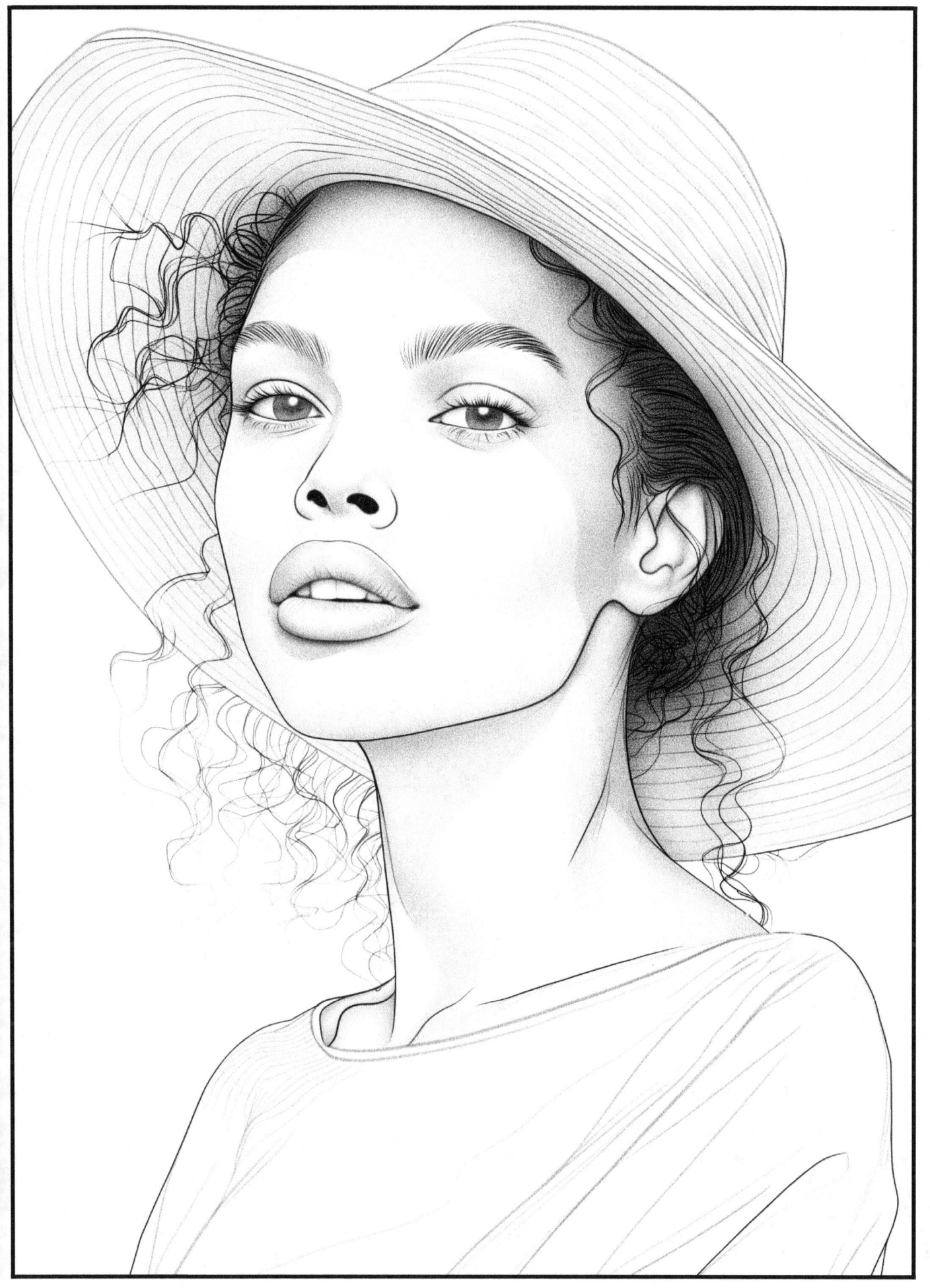

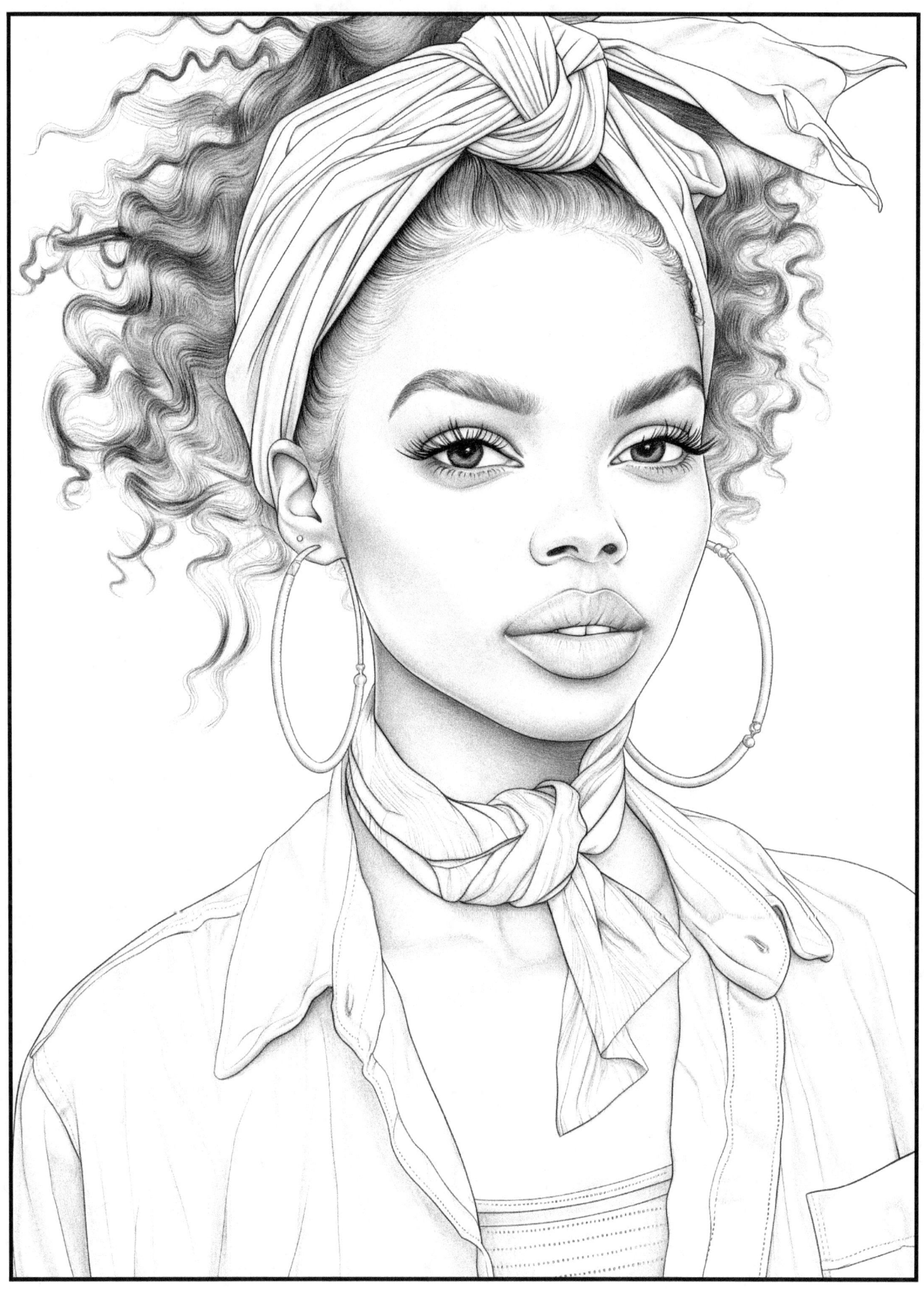

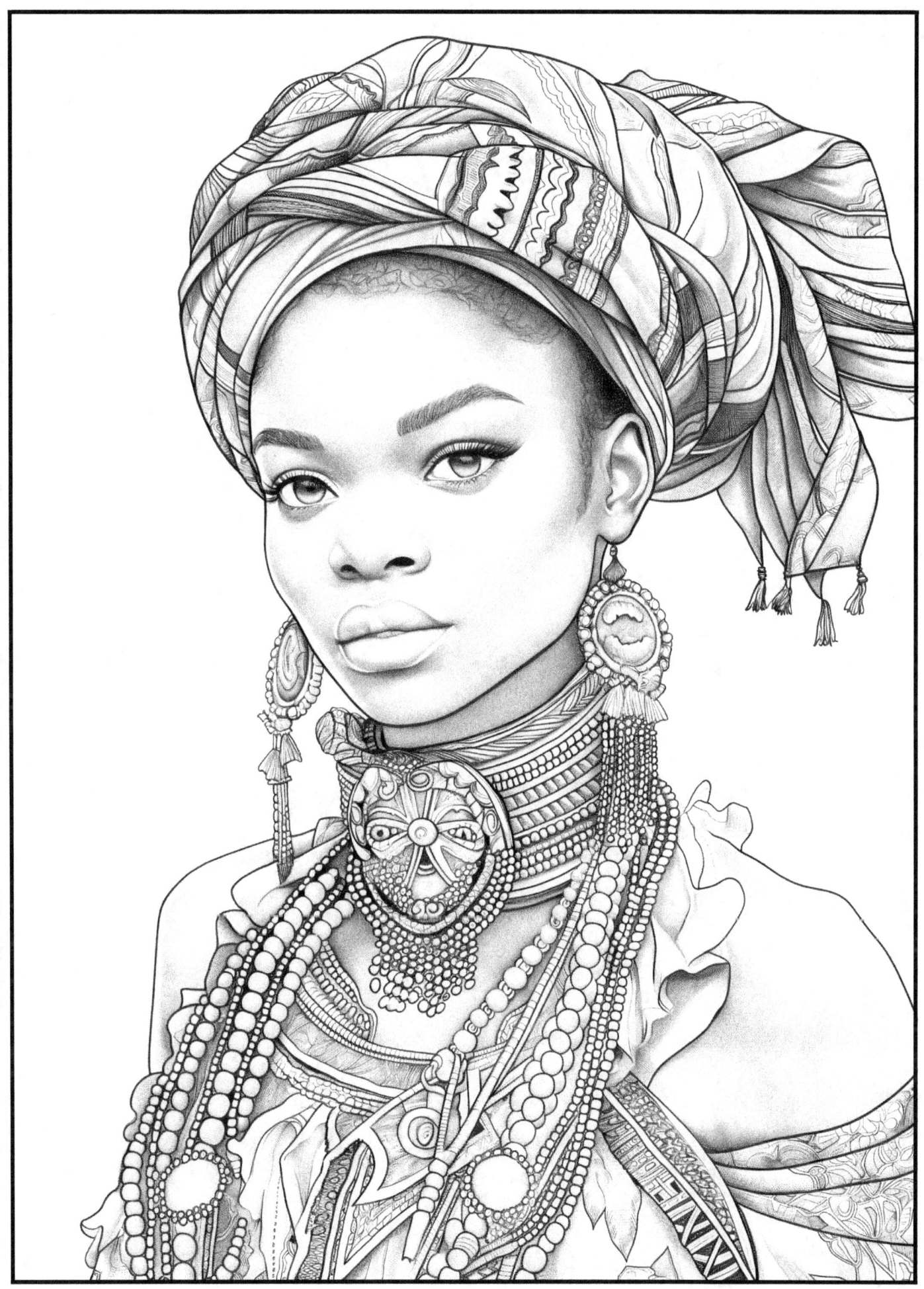

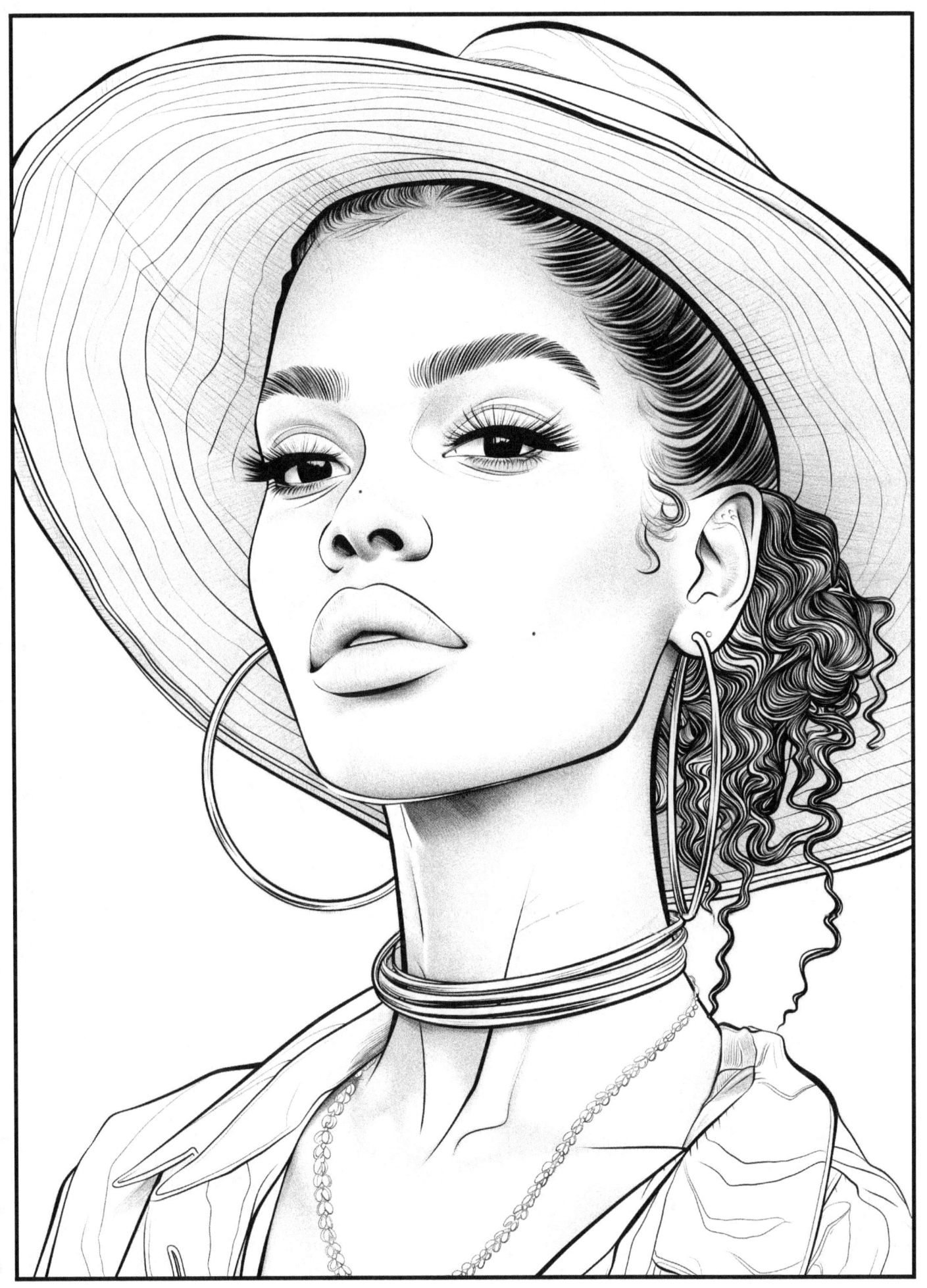

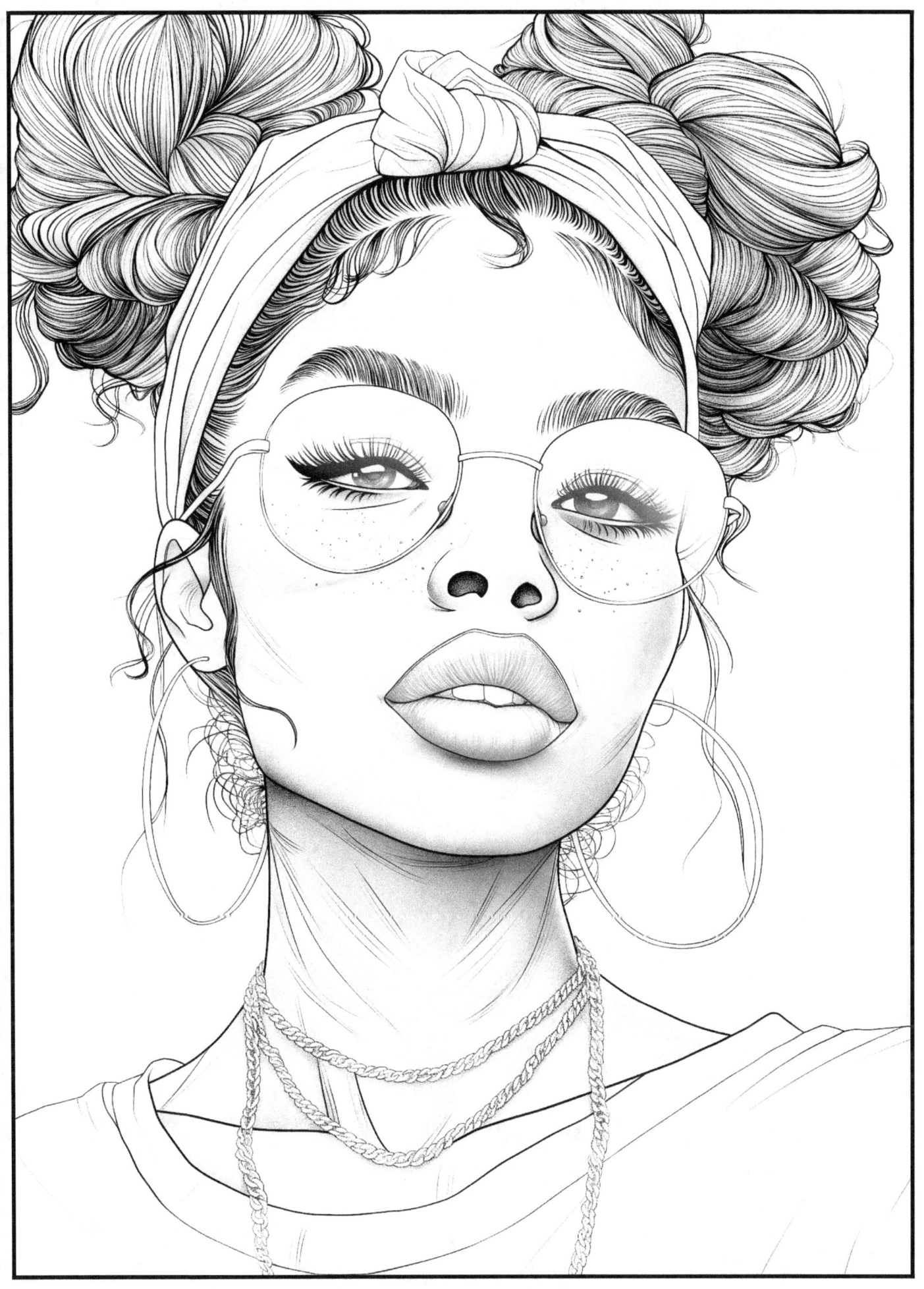

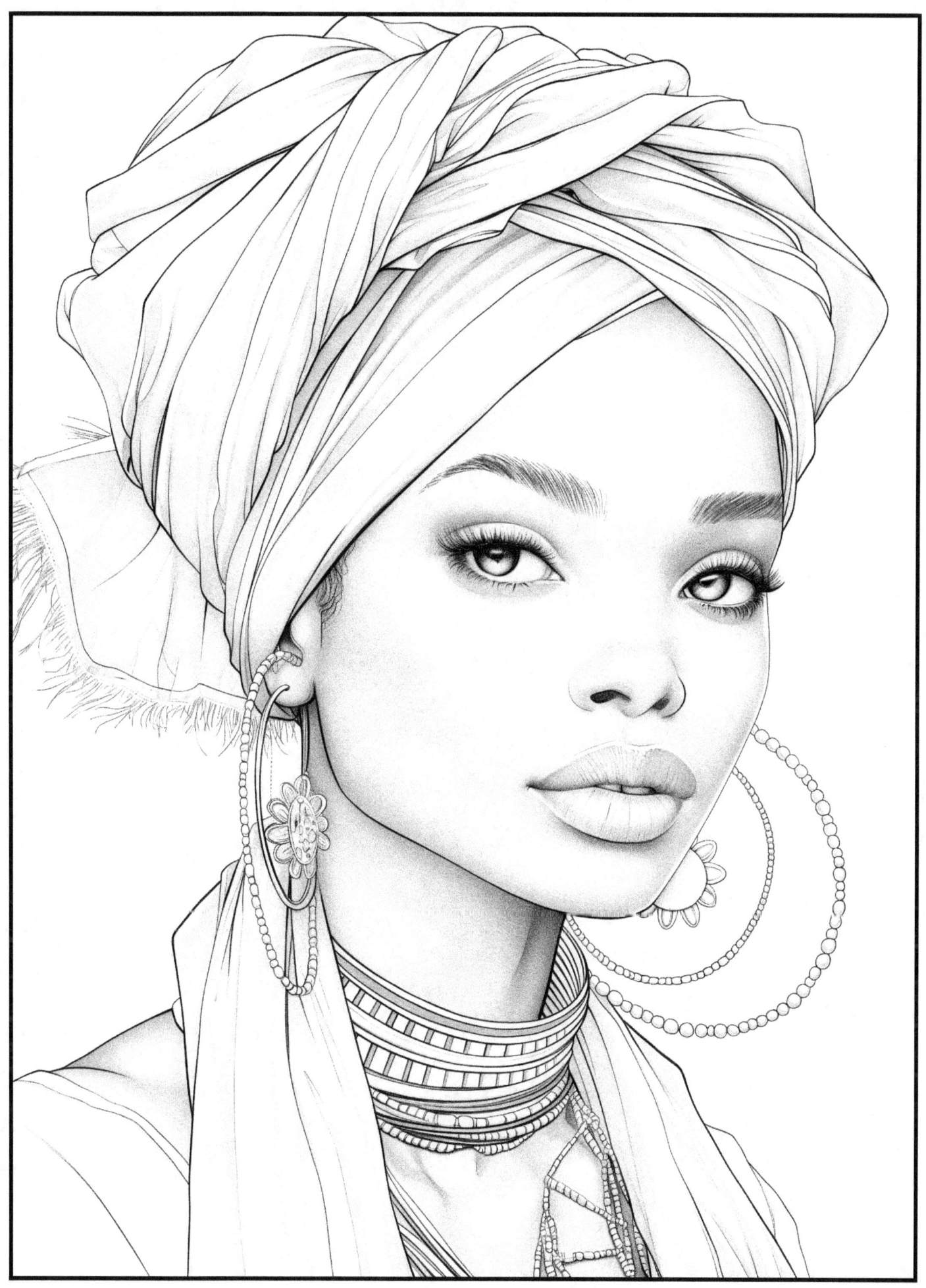

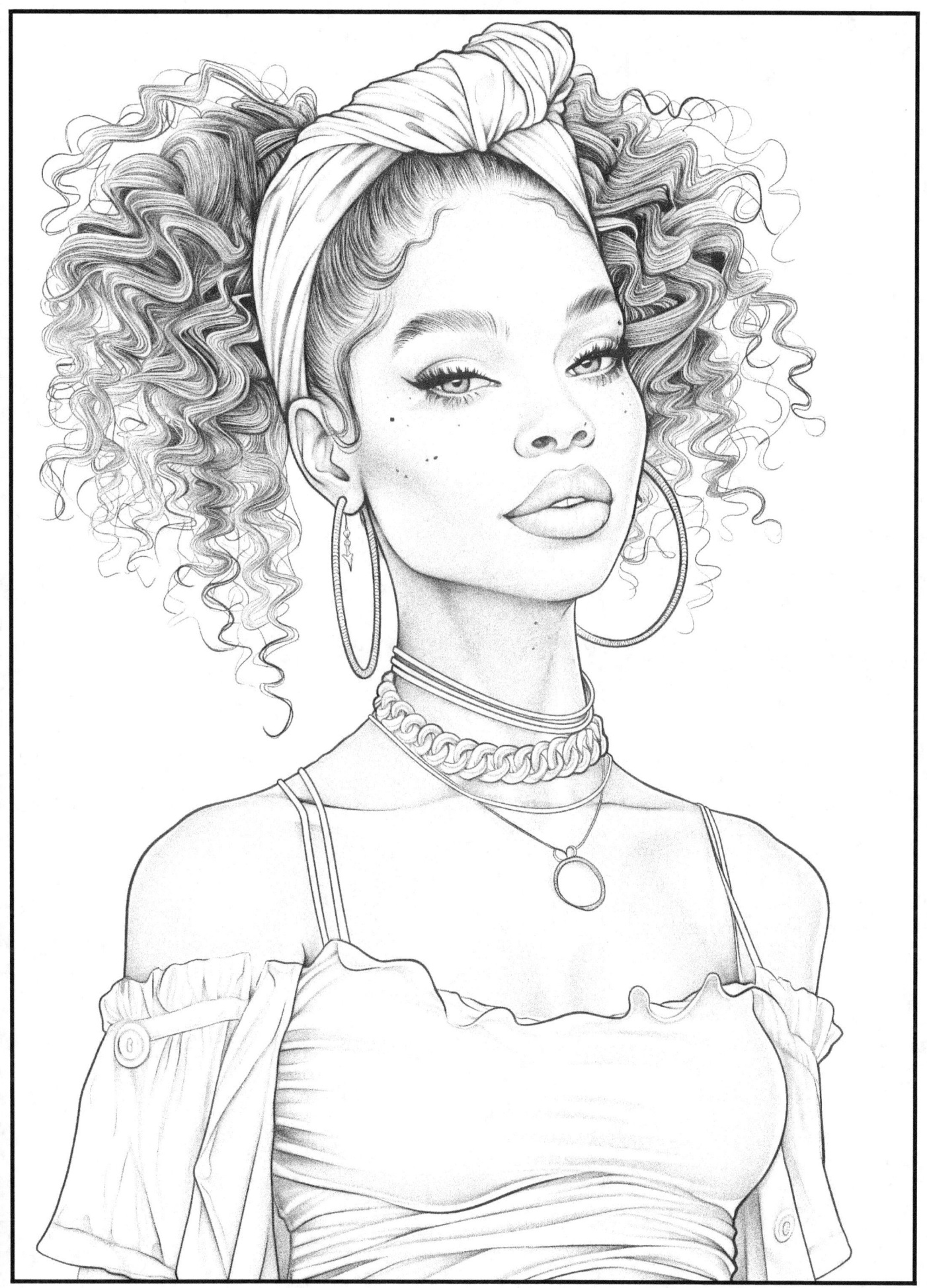

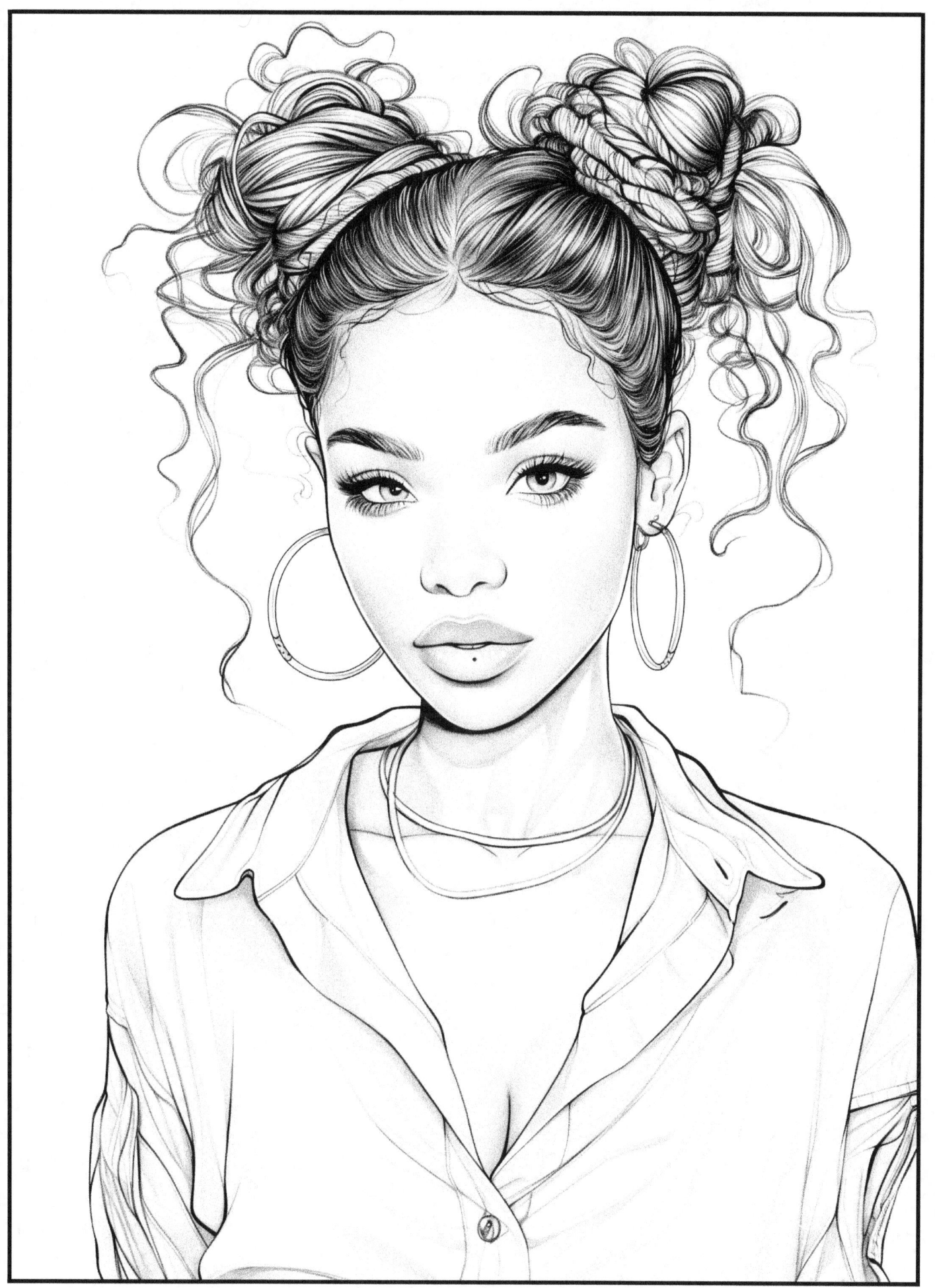

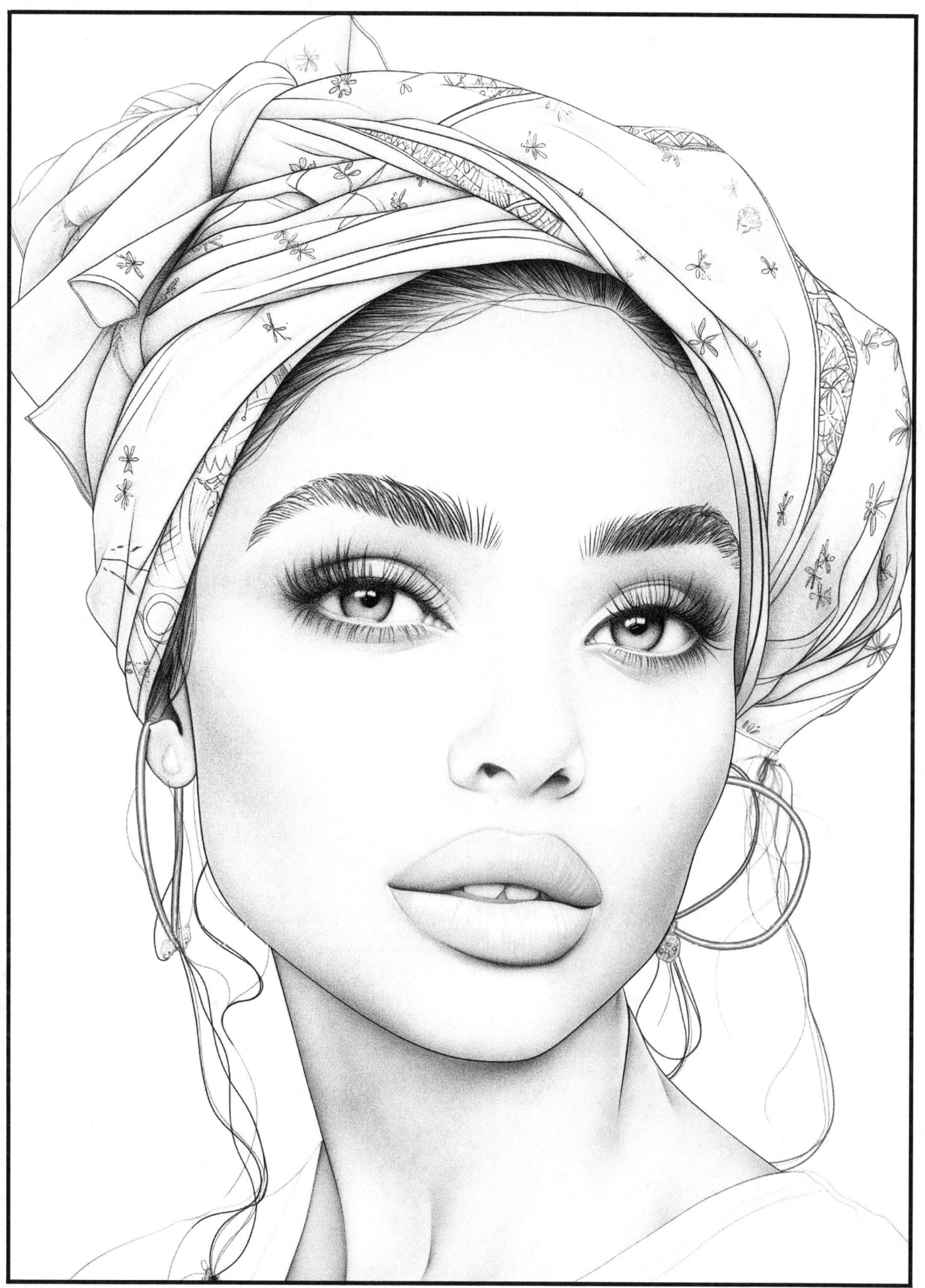

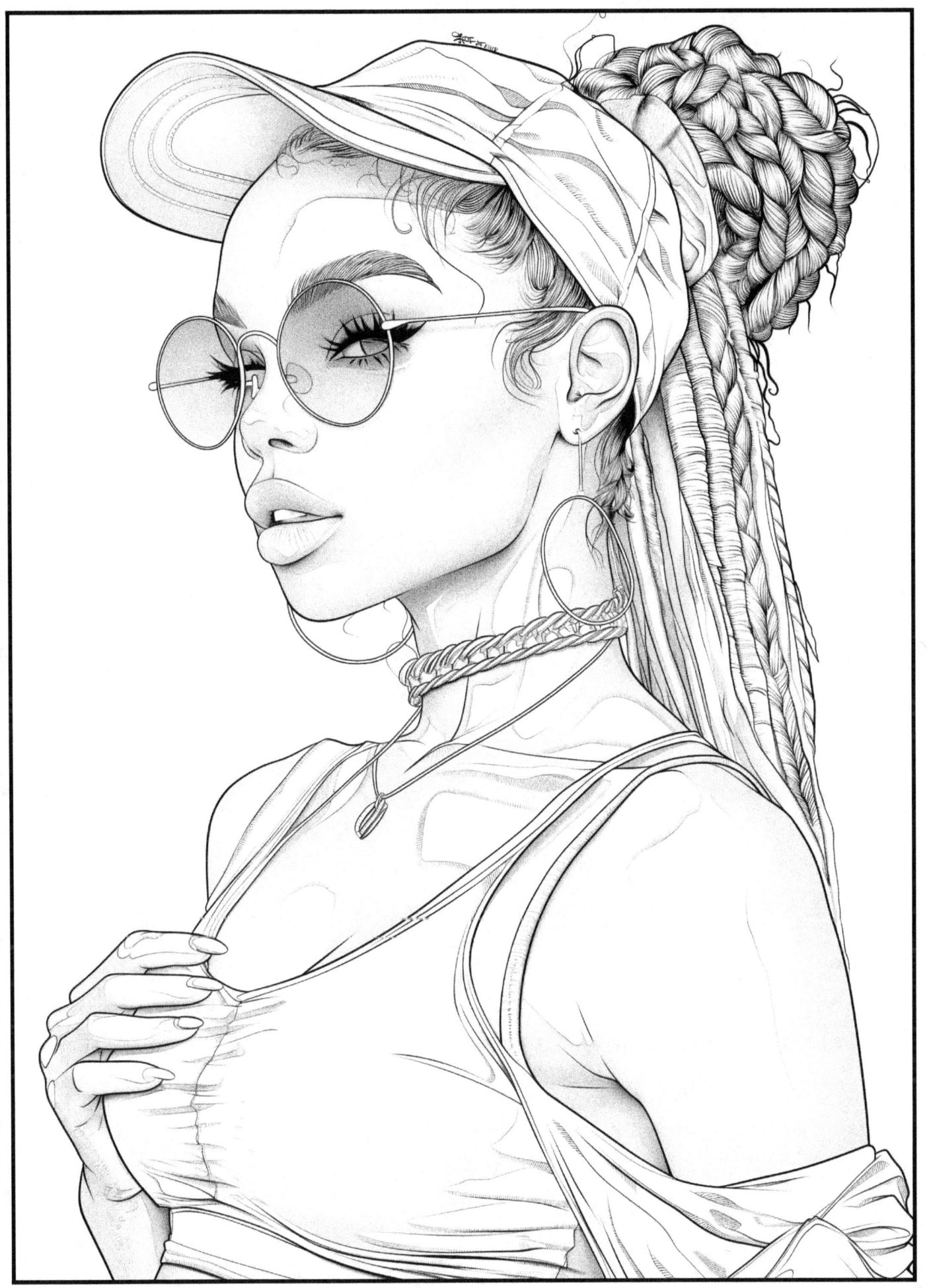

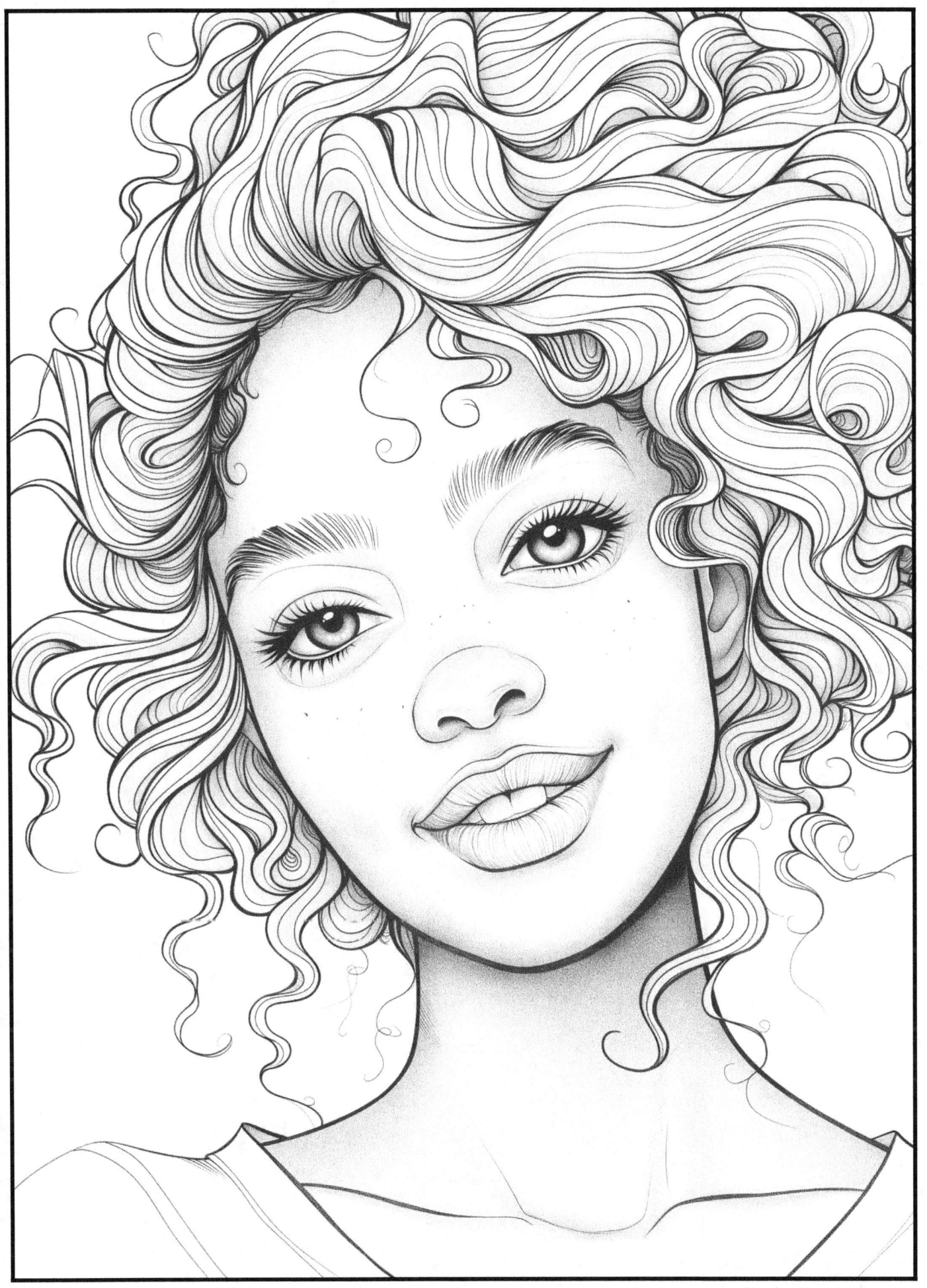

www.ingramcontent.com/pod-product-compliance
Lightning Source LLC
Chambersburg PA
CBHW062314220526
45479CB00004B/1167